How to be a Super Cartoonist

Written & Illustrated

By Peter Maddocks

Published By Peter Maddocks

And Marian Bonelli

©Peter Maddocks 2016

petermaddocksart.com

ISBN-13:978-1536891607

ISBN-10:1536891606

Peter Maddocks

RESEARCH BY PAT HUNTLEY

MY THANKS TO HER FOR ALL HER WORK AND TO ALL MY COLLEAGUES FOR THEIR VALUABLE CONTRIBUTION.

FIRST PUBLISHED IN GREAT BRITAIN 1985
BY ELM TREE BOOKS/HAMISH HAMILTON LTD.
GARDEN HOUSE 57-59 LONG ACRE LONDON WC2E 9JZ

BRITISH LIBRARY CATALOGUING IN PUBLICATION DATA

MADDOCKS, PETER

 HOW TO BE A SUPER CARTOONIST.
 1. CARTOONING
 I. TITLE
 741.5 NC1320

How interesting — do you do it full time or do you do other things? This is the kind of question you get asked when someone discovers what you do for a living — usually followed by a very vivid description of their own very favourite cartoon always drawn by someone other than yourself.

Make no mistake about it — cartooning is a tough business. To succeed you need the hide of a rhinoceros — the strength of a lion and if you're going to work in Fleet Street — the constitution of a horse. Then learn to live without long holidays or those carefree trips abroad.

As a topical cartoonist you've got deadlines to meet, news items to read, radio to listen to — you're trapped with one eye on your drawing board, another on the news and both ears on the ground...

Style is something you develop over the years and although it can change from time to time — I've changed mine three times in thirty years — it's still your trade mark.

Study the distinctive style of Steadman or Glashan — recognisable at a glance. Characters can produce a style, look at the Giles family — or Thelwell and his ponies. Noses can also create a style as with Larry or Calman or Dickens. Michael Heath never uses tint or solid black, drawing only in line. Calman only draws in pencil —

Trog and Cummings will use areas of solid black — unlike Garland who uses a softer line and loves those white open spaces as does ffolkes with his delicate line and decorative approach — all this is style, and like handwriting you can recognise who it belongs to without reading the signature.

With the topical cartoon you often have to show a placard displaying a news item as a pointer to your gag caption — this of course limits your visual detail and if you restrict yourself to drawing talking heads only, without background detail, it will look as if it's produced by a rubber stamp — so the design of the cartoon is important — make it look interesting as a drawing.

The caption is something not to be ignored — writing captions is a skill. Consider the work that goes into copywriting for advertising and you'll understand what I mean. It must all be there within as few words as possible — unless of course the drawing says it all...

When a new political face does appear on the scene each cartoonist has his own interpretation on how he or she will look — picking on some feature or attitude to make them instantly recognisable. Sometimes one of them will spot something that the others hadn't thought of —— just watch the others craftily fit it in within their own style until eventually even the victim seems to adjust their features to match the caricature.

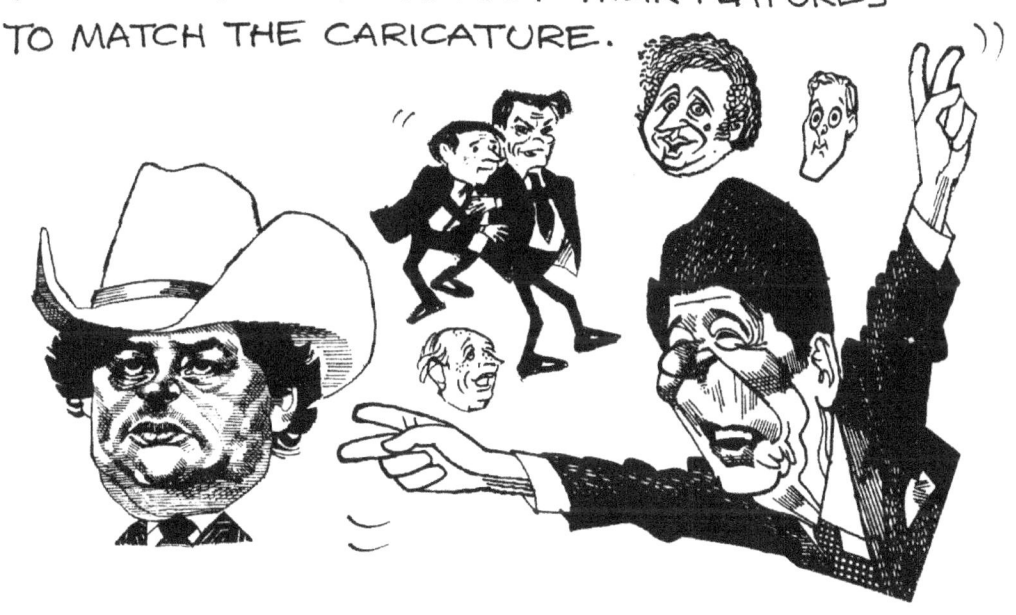

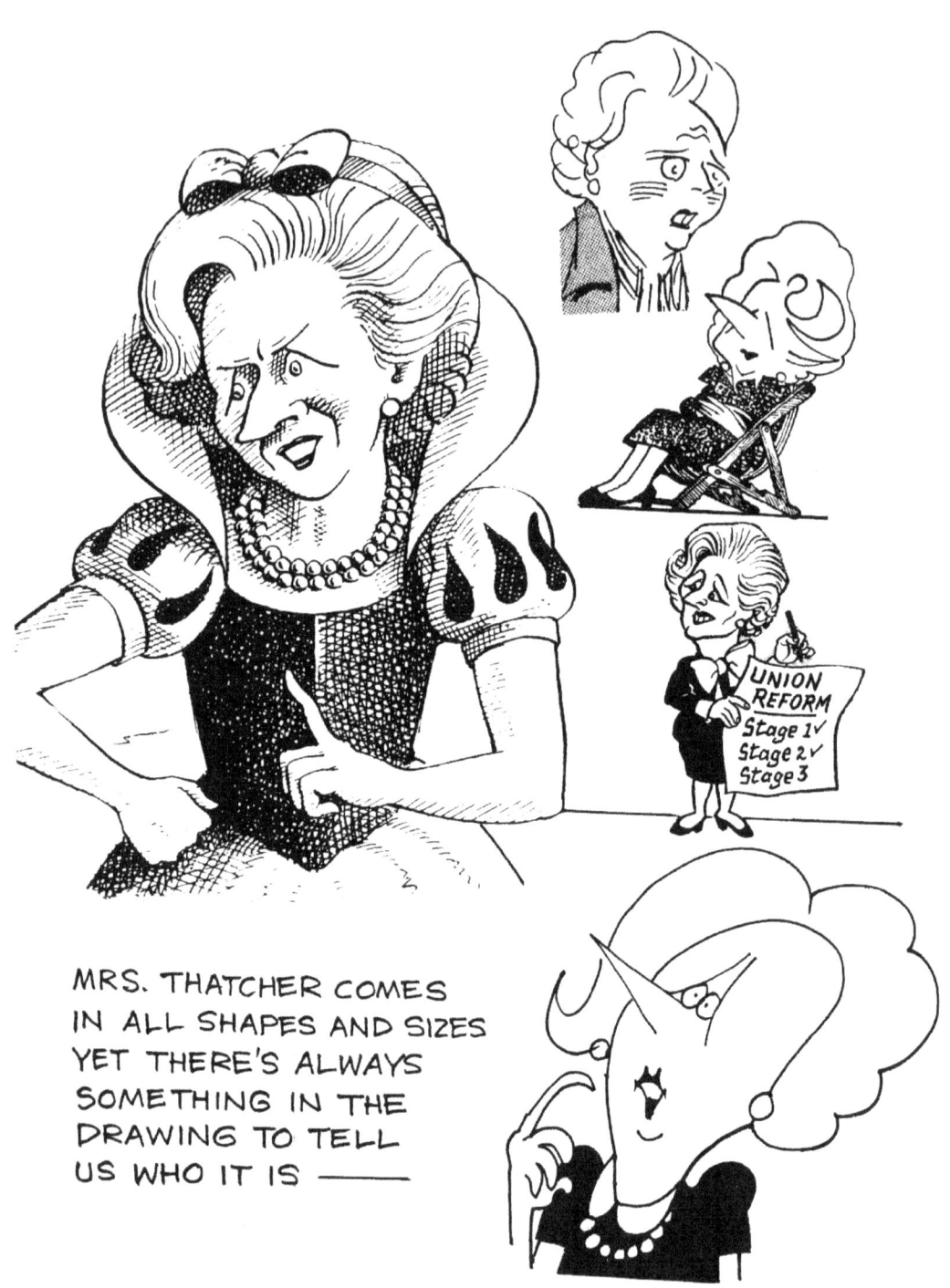

Pens

Many cartoonists use a Rotring pen, there are various sizes but I've always found a number 6 point is about the right weight— also good for lettering.

You'll also need to buy the drawing ink to go with it.

For simplicity and speed you can't beat the fibre tip pens they don't smudge, bleed or blot and you don't have to carry ink around with you— just a spare refill or two, great for roughs too, but if used for originals—beware, don't forget they will fade if framed and hung in daylight...

For paper or card go see your local art supplier —— I like to use cartridge paper for strip cartoons, but for general cartoons ——

Forget all that expensive card, use a good quality typing paper 85gsm A4 is good enough, then you can scribble & scratch trace or throw it away without any tears.

A ream is 500 sheets

As for art board — it depends on what surface you like to work on, smooth, hard, or a soft rough surface (ideal if you are going to use a black crayon in your artwork).

Each of the cartoonists in this book point out various sorts of paper and card they prefer to use, so you can judge for yourself as you read through the book."

SCALING UP OR SCALING DOWN IS EASY ENOUGH IF YOU FOLLOW THIS SIMPLE RULE ———

WHEN SOMEONE GIVES YOU A SIZE FOR THE ARTWORK REQUIRED, IT'S USUALLY A PRINTING SIZE — TO HELP YOU SCALE UP TO YOUR NATURAL DRAWING SIZE JUST DRAW UP THE PRINT SIZE ON YOUR LAYOUT PAD AND RUN A DIAGONAL LINE FROM THE TOP LEFT HAND CORNER TO THE BOTTOM RIGHT.

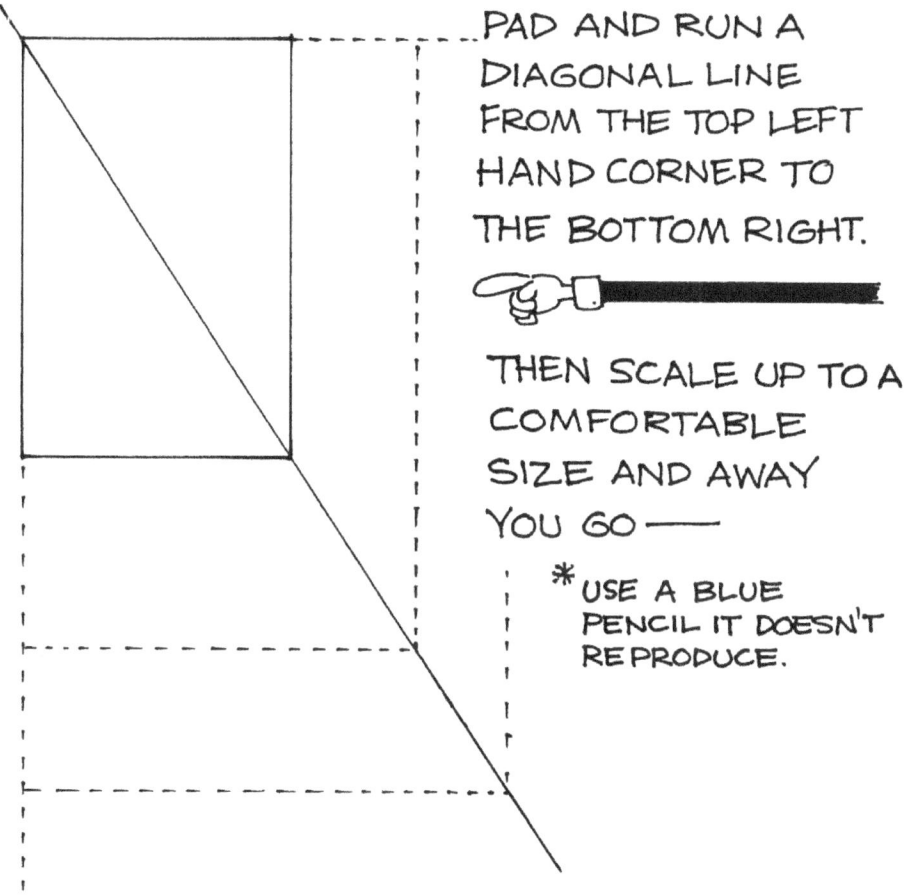

THEN SCALE UP TO A COMFORTABLE SIZE AND AWAY YOU GO ——

*USE A BLUE PENCIL IT DOESN'T REPRODUCE.

DON'T PANIC — REACH FOR THAT PROCESS WHITE AND PAINT OVER YOUR CLANGER, THEN WAIT FOR IT TO DRY———

BUT IF YOU'VE JUST DRAWN A CROWD OF TEN THOUSAND HORSEMEN AND MADE A MAJOR BLUNDER——— DON'T START ALL OVER AGAIN...

GET THOSE SCISSORS OUT, CUT OUT A PATCH OF FRESH WHITE PAPER AND FIT IT OVER THE OFFENDING CLANGER AND GUM IT DOWN—

THEN CONTINUE WITH THE DRAWING

REMEMBER: BLOOD & TEARS WILL RUIN ARTWORK

THE STRIP CARTOON

WHEN DRAWING A STRIP CARTOON TO SUBMIT TO AN EDITOR IT COULD BE USEFUL IF YOU DESIGNED IT TO WORK IN 3 SHAPES —

BECAUSE OF SPACE PROBLEMS SOME NEWSPAPERS LIKE TO BE IN A POSITION TO JUGGLE THE LAYOUT OF A STRIP CARTOON TO FIT IN THAT LAST MINUTE ADVERTISING SPACE. THIS WAY THEY CAN RUN IT HORIZONTAL, VERTICAL OR IN A BLOCK OF FOUR...

WELL WORTH THINKING ABOUT WHEN SUBMITTING A STRIP CARTOON FOR PUBLICATION.

Once you design a strip cartoon and its characters you're stuck with it. But then a gradual change will take place over the years — if you look at the Peanuts strip (then called Charlie Brown) back in the fifties you will see that the characters are almost unrecognisable compared with today —

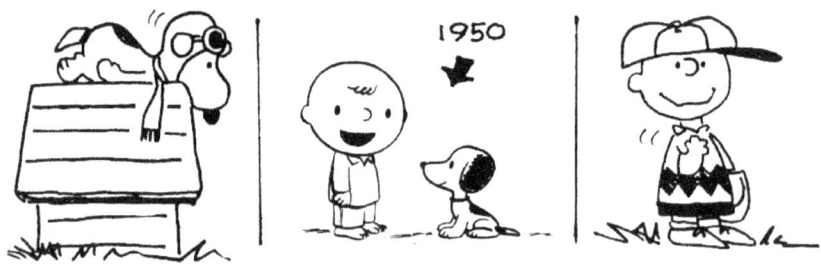

The Standard's —
Augusta strip started life as a boy called Clive until his little sister appeared and dominated the strip.

Poelsma

An artist named John McLusky was the first to give James Bond a face in the Daily Express strip cartoon back in 1965 — it is rumoured that the actor Sean Connery was cast for the films on the likeness to the character in the strip cartoon...

Peter O'Donnell's creation Modesty Blaise was first given a face by artist Jim Holdaway in 1963, who drew her until his untimely death in 1970 — two or three artists have struggled to capture her original likeness ever since.

JAK'S REAL NAME IS RAYMOND JACKSON BUT I'VE NEVER HEARD ANYONE CALL HIM ANYTHING DIFFERENT. HE'S BEEN JAK TO EVERYONE IN THE LONDON STANDARD SINCE 1960 AND HIS PRESENT CONTRACT WITH THEM CONTINUES UP UNTIL 1991 —— THAT'S HOW SURE THEY ARE OF HIS POPULARITY.

A2
LAYOUT PAD
2B PENCIL

HE TRAVELS TO WORK BY CAR EACH MORNING TO ARRIVE AT HIS OFFICE IN THE EXPRESS BUILDING BY 7.30 AM.

HIS OFFICE IS THE ONE WITH THE SIGN HANGING ON THE DOOR →

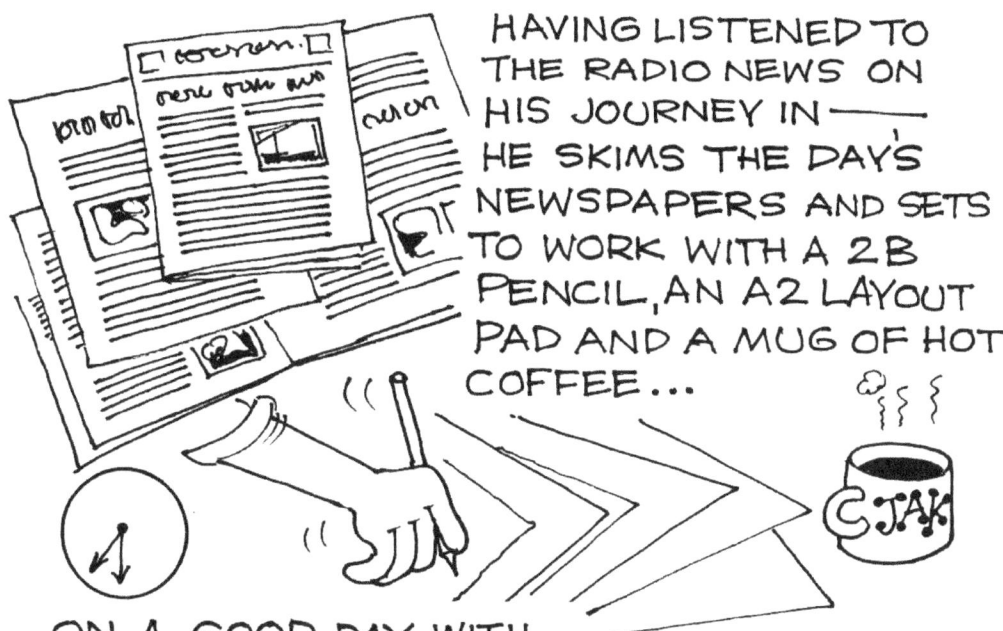

HAVING LISTENED TO THE RADIO NEWS ON HIS JOURNEY IN — HE SKIMS THE DAY'S NEWSPAPERS AND SETS TO WORK WITH A 2B PENCIL, AN A2 LAYOUT PAD AND A MUG OF HOT COFFEE...

ON A GOOD DAY WITH LOTS OF NEWS ITEMS HE CAN HAVE AS MANY AS SIX IDEAS BUT USUALLY PRODUCES TWO OR THREE ROUGHS TO TAKE IN TO THE EDITOR.

 BY 9.30 AM. HE GOES INTO THE EDITOR'S OFFICE WHERE BETWEEN THEM THEY DECIDE ON THE CARTOON — JAK ALWAYS SHOWS THE EDITOR HIS IDEAS AND ON SUNDAYS WHEN HE WORKS ALONE HE WILL DISCUSS THE IDEA BY TELEPHONE — CARTOONISTS ARE OFTEN ASKED IF THEY ARE TOLD WHAT SUBJECT TO DRAW AND THE ANSWER IS **No** — BUT YOU ALWAYS DISCUSS IT WITH YOUR EDITOR.

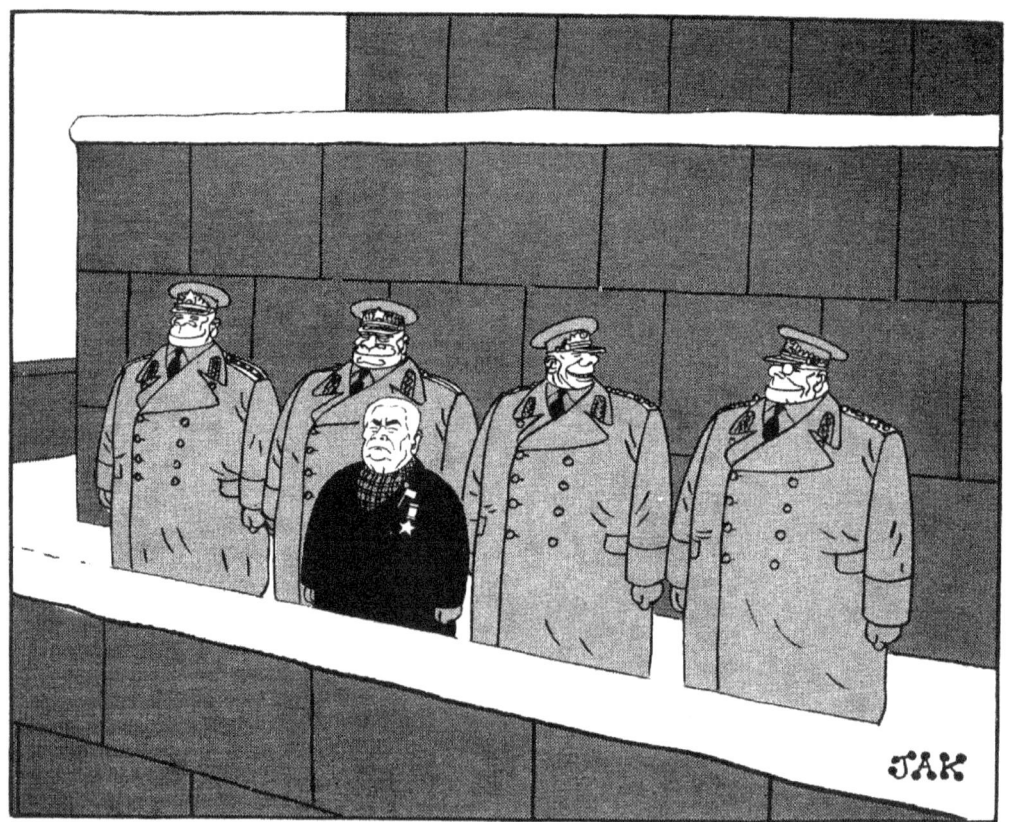

"Actually, he's got a great sense of humour. I remember a joke he told in 1924 . . . !"

ONCE THE CARTOON IDEA IS CHOSEN —
IT'S BACK TO JAK'S CABIN WHERE
HE TELEPHONES THE PICTURE LIBRARY
AND ORDERS REFERENCE PHOTOGRAPHS
ON HIS SUBJECT. — PUBS, PLANES,
CARS, BUILDINGS ETC.
DETAIL IS VERY IMPORTANT
FOR A FIVE COLUMN TOPICAL
CARTOON ALWAYS BASED ON
FACT NOT FANTASY — SO IT
MUST LOOK RIGHT.

JAK USES CS6 ABRADED
BOARD FOR FINISHED
ARTWORK — HE ALWAYS
DRAWS THE SAME SIZE
17" x 21½" REDUCING TO
FIVE COLUMNS.
EVERYTHING IS FIRST DRAWN
IN PENCIL, EVERY DETAIL
INCLUDING THE CAPTION.

HE THEN DRAWS WITH A BRUSH AND PELIKAN INK.
HE USED TO USE A MAPPING PEN BUT WAS
CONTINUALLY BREAKING THE NIBS ✳6☆!!
SO HE STARTED TO USE A BRUSH AND
FELL IN LOVE WITH IT...

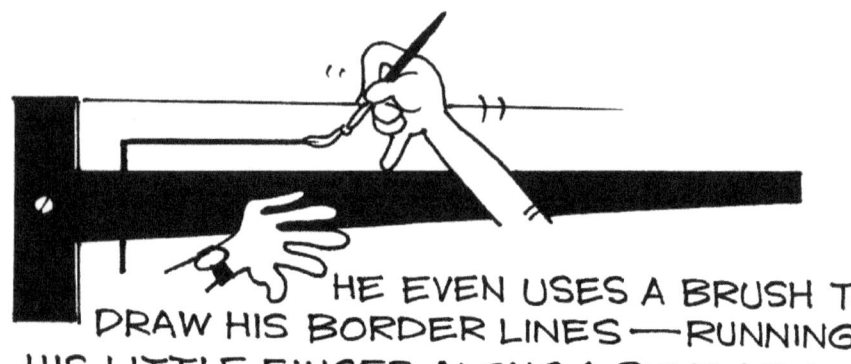

HE EVEN USES A BRUSH TO DRAW HIS BORDER LINES — RUNNING HIS LITTLE FINGER ALONG A RULE AS A GUIDE.

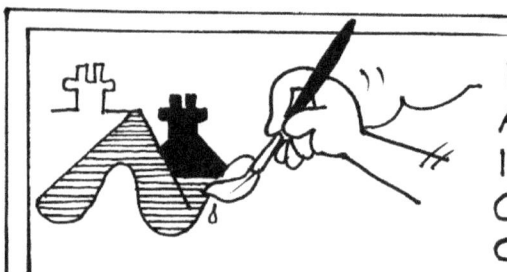

FOR TINT HE USES A BRUSH AND PALE BLUE INK — NOT JUST SLAPPED ON, BUT WELL THOUGHT OUT BEFOREHAND.

JAK HAS A GREAT EYE FOR LIGHT AND SHADE AND I ENVY IT ——————— NOTICE ALSO THAT HE ALWAYS DRAWS A HAND WITH THREE FINGERS AND A THUMB, THIS IS A THROW BACK TO THE DISNEY ERA WHEN ANIMATORS ONLY DREW THREE FINGERS FOR ECONOMY — WHEN YOU'RE DOING THOUSANDS OF DRAWINGS THAT'S A LOT OF FINGER WORK SAVED —— HOWEVER WITH JAK IT'S JUST A STYLE OF DRAWING.

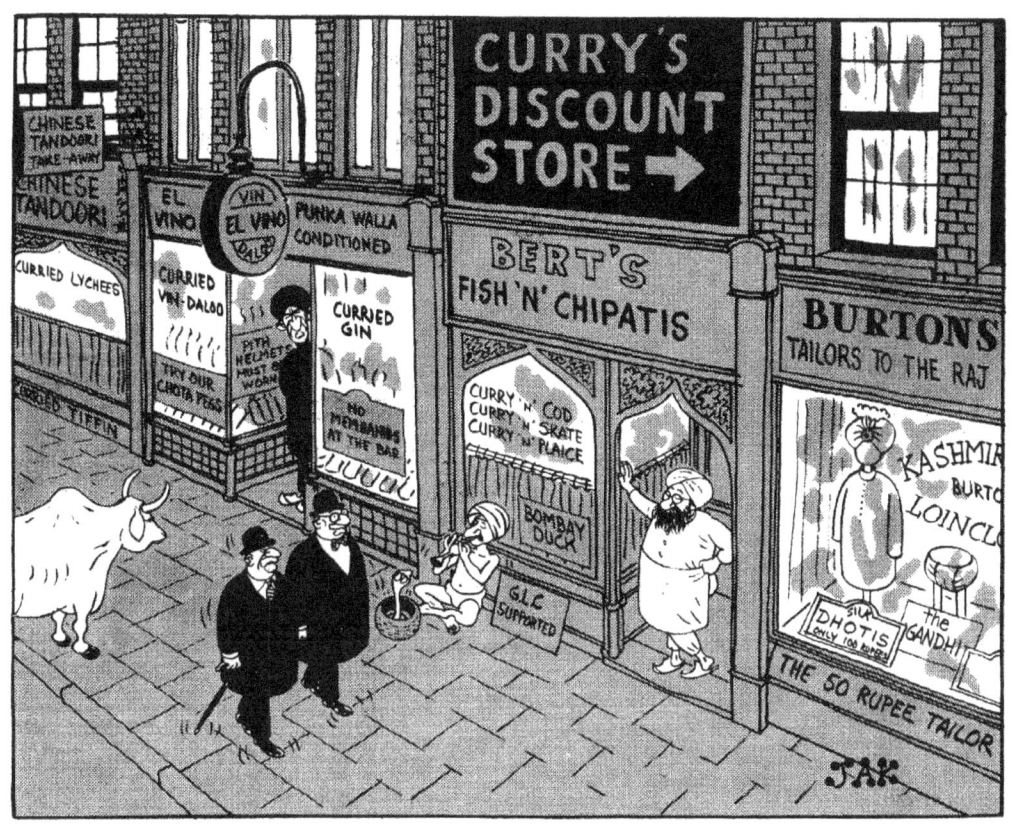

"I shall be glad when all this blasted Indian television stuff is over!"

↗ BY 1·0 PM THE CARTOON IS USUALLY FINISHED AND JAK IS READY FOR A LONG LUNCH——
FIRST A SPRAY OF FIXATIVE TO PROTECT THE ARTWORK (THIS WILL CLEAR THE ROOM OF VISITORS COUGHING AND CHOKING). HIS ARTWORK IS ALWAYS IN DEMAND AND MOST IS PURCHASED BY ADMIRERS AND SOME IS GIVEN TO CHARITY.

JAK ADMIRES RONALD SEARLE, OLIPHANT AND STEADMAN FOR HIS DRAUGHTMANSHIP, AND OF COURSE GILES HAS BEEN A GREAT INFLUENCE ——— HE TELLS THE STORY OF A MAN WHO WANTED TO PURCHASE ONE OF HIS CARTOONS, A PRICE WAS AGREED AND HE WAS INVITED TO JAK'S CABIN TO CHOOSE A CARTOON FROM HIS STOCK —— AFTER BUSILY SORTING THROUGH THE ARTWORK THE MAN COMPLAINED THAT HE COULDN'T FIND ONE CARTOON WITH A GRANNY IN IT.

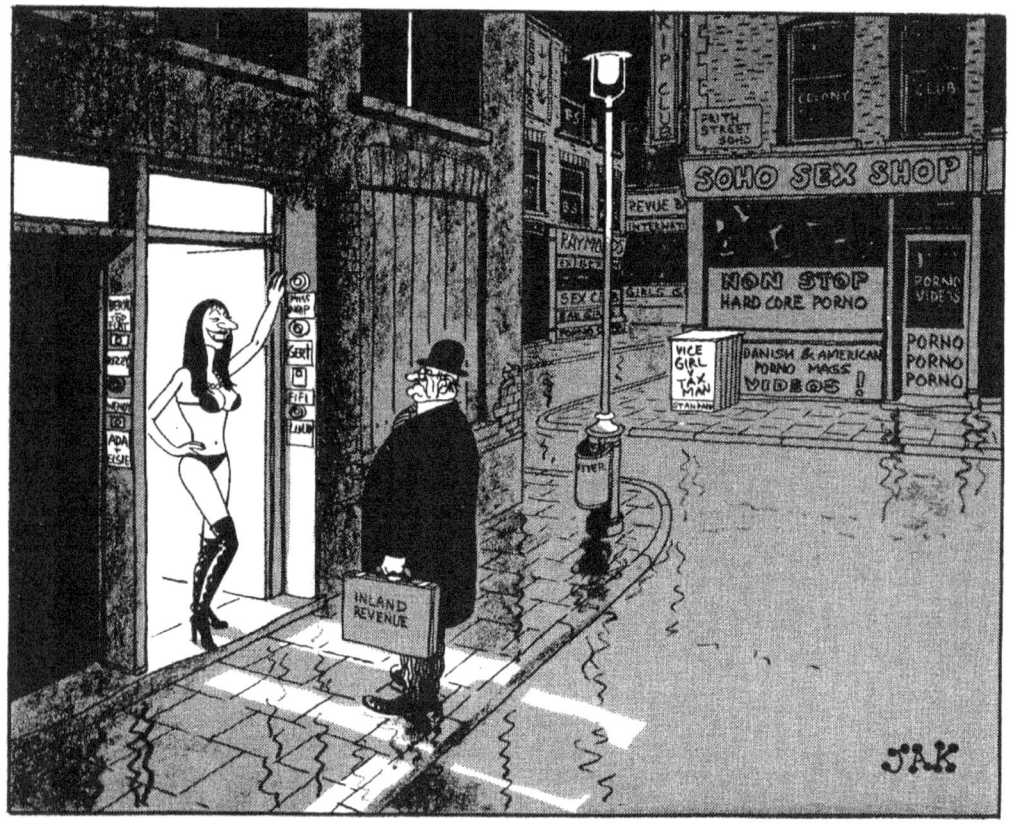

"So you're a tax inspector, darling. Who in your office recommended me?"

SIMON BOND

SIMON BOND CREATED A BOOK CALLED A HUNDRED AND ONE USES OF A DEAD CAT AND IT SOLD AND SOLD MAKING HIM LOTS OF MONEY. YET WHEN I TALKED TO HIM ABOUT HIS WORK HE TOLD ME HE HATED DRAWING —— HIS REAL LOVE IS THINKING UP THE IDEAS, THESE COME EASILY TO HIM —— SO HE CARRIES A NOTEBOOK AND WRITES THEM DOWN AND THEN WORKS THEM UP INTO DRAWINGS LATER. THE DRAWING CAN TAKE FOREVER, HE SAID, BUT HE CAN GET AN IDEA IN A FLASH...

SO HE WOULD RATHER HAVE AN IDEA REJECTED BEFORE HE DRAWS IT UP —— I ONCE PAPERED MY STUDY WITH REJECTION SLIPS HE SAID.
 (AT LEAST HE FOUND A GOOD USE FOR THEM, I NEVER DID.)

HE WORKS IN A SMALL BASEMENT STUDY
OF HIS LOVELY HOME, JUST AROUND
THE CORNER FROM HARRODS,
DRAWING VERY
DETAILED ROUGHS
WITH AN HB PENCIL ON
A4 CARTRIDGE PAPER AND
WORKING OVER HIS
PENCIL DRAWINGS WITH
A FINE NIKO NEEDLEPOINT NYLON TIP.*
EACH DRAWING TAKES ABOUT 1 HOUR.
AND SIMON SAYS HE FINDS IT VERY HARD
WORK ANY MISTAKES HE USES TIPPEX.
HE NEVER PATCHES (WELL PERHAPS NOW AND
AGAIN) BUT HE CERTAINLY
DOESN'T OBJECT TO IT.
HE DRAWS ABOUT TEN CARTOONS AND
THEN SELF EDITS BY PUTTING <u>SIX</u>
CARTOONS IN WHAT HE CONSIDERS TO BE
THE RIGHT ORDER HOPING THEY OPEN
THE ENVELOPE THE RIGHT WAY...

HE SAYS, SELF DISCIPLINE IS VERY IMPORTANT IN THIS BUSINESS, ESPECIALLY WHEN THE SUN IS SHINING. THAT'S WHAT HE LIKES ABOUT BOOKS — THEY ARE ALWAYS COMMISSIONED AND YOU KNOW THAT EVERY DRAWING WILL BE USED ——
HE ALWAYS WORKS SAME/SIZE FOR BOOKS, MAKING A CUT-OUT MASK WITH CARD AND DRAWS HIMSELF A FRAME IN BLUE PENCIL
THEN THE DRAWING CAN SIT VERY COMFORTABLY WITHIN THAT SPACE.
FOR HIS PUNCH AND NEW YORKER DRAWINGS HE DRAWS 9½" x 11½" AT THEIR REQUEST AND <u>NEVER</u> USES WASHES OR TINTS —— IT'S ALL ONE WAY WITH HIM, UP AND DOWN, HE NEVER CROSS HATCHES BECAUSE EVERYBODY ELSE DOES.
—— OH AND BY THE WAY, HE SAID AS I LEFT, DON'T HANG MY DRAWINGS IN DAYLIGHT BECAUSE LIKE OLD SOLDIERS, THEY ONLY FADE AWAY...

* (THAT'S WHAT HAPPENS WHEN YOU DRAW WITH FIBRETIP)

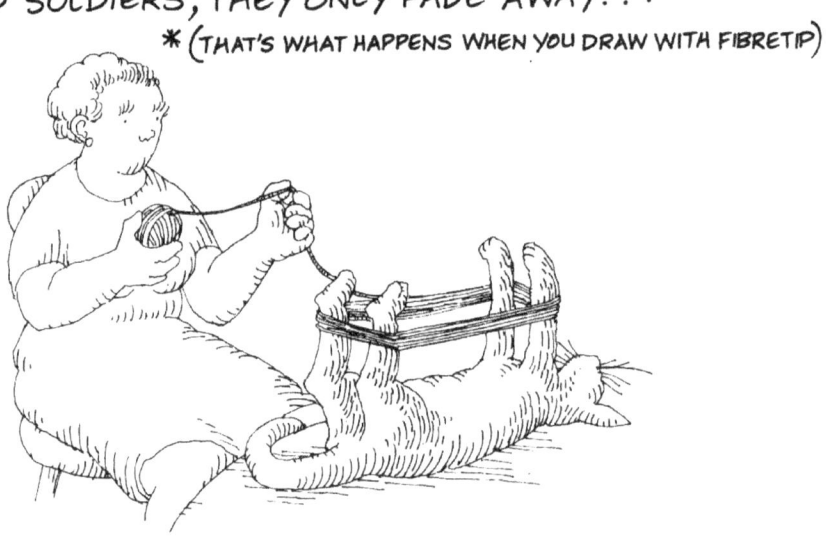

(ALIAS WALLY FAWKES)

WALLY FAWKES WORKS FROM HIS HOME IN NORTH LONDON DURING THE WEEK DRAWING HIS FLOOK STRIP FOR THE DAILY MIRROR—
ON FRIDAYS HE GOES TO THE OBSERVER NEWSPAPER TO WORK ON HIS POLITICAL CARTOON, DURING THAT AFTERNOON HE MEETS WITH KEITH WATERHOUSE TO WORK OUT NEXT WEEK'S FLOOK EPISODE (IAN WOOLDRIDGE CLAIMS IT TO BE THE GREATEST PARTNERSHIP SINCE HOBBS AND SUTCLIFE) THEY WORK OUT FIVE STRIPS FOR THE DAILY— AND ONE FOR THE SUNDAY MIRROR.
EACH FLOOK STRIP TAKES ABOUT ONE HOUR TO DO THE FINISHED DRAWING

 WALLY FAWKES'S DAY STARTS BY READING THROUGH ALL THE NEWSPAPERS AND LISTENING TO NEWS BROADCASTS ON THE RADIO — ON T.V. HE FINDS THAT ROBIN DAY'S QUESTION TIME GIVES HIM A GOOD POINTER TO THE POLITICAL TOPICS BEING DISCUSSED THAT WEEK. HE STARTS DOING ROUGHS ON WEDNESDAY — NO EARLIER BECAUSE HE'S DRAWING FOR A SUNDAY PAPER AND THE POLITICAL CLIMATE MAY CHANGE BY FRIDAY. IT'S IMPORTANT TO BE AS TOPICAL AS POSSIBLE — BY FRIDAY THE IDEA IS MAPPED OUT (THERE MAY BE MORE THAN ONE IDEA, BUT HE REJECTS THEM HIMSELF AND MAKES A FINAL CHOICE) HE THEN WORKS ON THE CHOSEN CARTOON, LISTENING TO L.B.C. RADIO NEWS TO KEEP UP TO DATE — THE FINISHED ARTWORK FOR THE POLITICAL CARTOON CAN TAKE ANYTHING BETWEEN THREE TO FOUR HOURS TO COMPLETE...

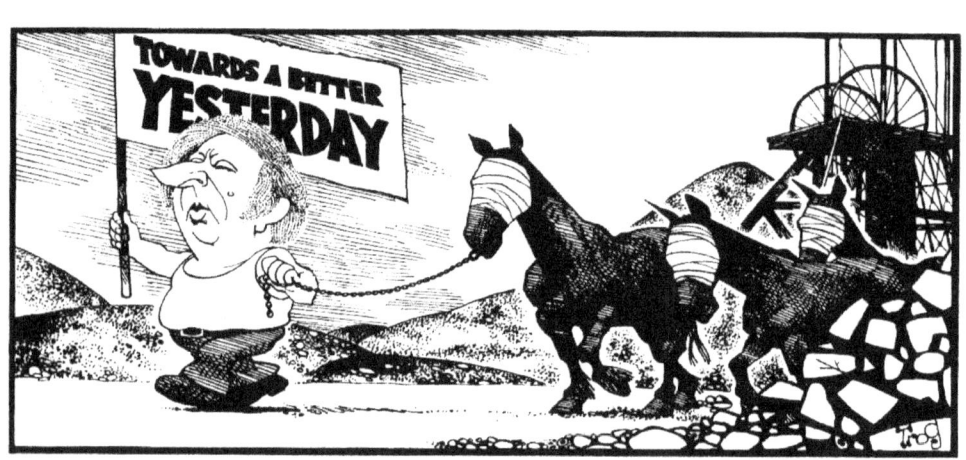

He sits at his desk with a raised drawing board working on either Truline or Bristol board — Higgins black ink and a dip pen with a Gillot 291 nib. A fine brush for filling in the black areas, blanking out with Tippex — he likes to do his roughs with a brush to give a freer feel — so that when he comes to do the finished drawing in pen he doesn't feel he's doing the same drawing all over again. Wally's only distraction is cricket — he's been known to leave his desk and head in the direction of Lords/Oval for the rest of the day.

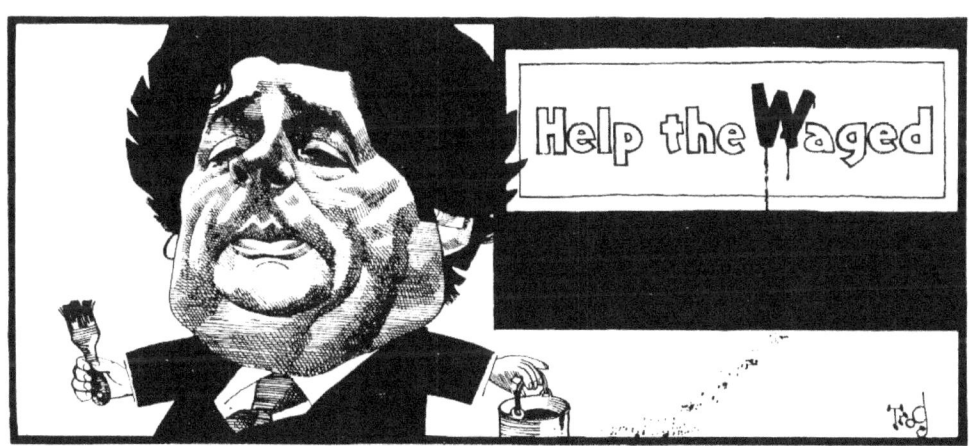

Calman

MEL CALMAN RUNS THE CARTOON GALLERY IN LONDON'S LAMBS CONDUIT STREET WC1. HE DRAWS THE FRONT PAGE POCKET CARTOON FOR THE TIMES EACH DAY PLUS VARIOUS MAGAZINES (COSMOPOLITAN, HOUSE & GARDEN), ADVERTISING, BOOKJACKETS, AND SEVERAL BOOKS OF HIS OWN CARTOONS (ONE A YEAR FOR THE PAST SIX YEARS). HE DRAWS IN HIS SMALL OFFICE AT THE GALLERY OR IN THE DESIGN DEPARTMENT OF THE TIMES (SHARED WITH FELLOW CARTOONIST PETER BROOKES) OR IN HIS STUDIO AT HOME HIGH ABOVE LONDON'S COVENT GARDEN. BEING A TOPICAL CARTOONIST HIS DAY STARTS WITH BREAKFAST TELEVISION.

MEL CALMAN ALWAYS WORKS IN PENCIL — 4B AND 5B FOR DRAWING AND 4B FOR HIS LETTERING (NEVER IN INK). HE DRAWS FLAT ON THE DESK (NO BOARD). HAVING LISTENED FOR EARLY NEWS ITEMS AND LISTENED TO RADIO AT THE GALLERY DURING THE DAY HE LEAVES AT 4.30 PM TO GO TO THE TIMES NEWSPAPER OFFICE TO WORK OUT TWO OR THREE IDEAS TO TAKE TO THE NIGHT EDITOR FOR APPROVAL — ONCE AGREED HE WORKS ON CROXLEY SCRIPT PAPER FOR THE FINAL ARTWORK USING A TEMPLATE FOR THE FRAME BOX — ALTHOUGH THE DRAWING MAY LOOK VERY SIMPLE (THE FINAL DRAWING TAKES ABOUT TEN MINUTES) A LOT OF WORK GOES INTO THE CARTOON TO ACHIEVE THIS LOOK.

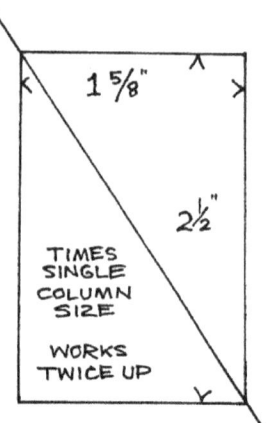

HE LIKENS CARTOONING TO BEING MARRIED, YOU HAVE TO KEEP WORKING AT IT ALL THE TIME IF YOU WANT TO SUCCEED WITH IT AND ALTHOUGH THE LITTLE MAN HE DRAWS IS *NOT* MEL CALMAN...

HE KNOWS HIM WELL — EVEN KNOWS EXACTLY WHAT HIS VOICE SOUNDS LIKE. HE TOO DOESN'T LIKE BEING INTERRUPTED WHILE HE'S THINKING UP IDEAS OR DRAWING. THEY ALSO LIKE THE SAME MUSIC, JAZZ AND LOTS OF MOZART —— APART FROM THIS THEY HAVE NOTHING IN COMMON.

Peter O'Donnell is not a cartoonist—
he is a writer, he has written for many strip
cartoons over the years — Romeo Brown,
Tug Transom, Garth and many others.
But now he writes just one — his own
creation, Modesty Blaise — a famous
adventure strip appearing daily in the
Standard newspaper and syndicated
around the world.

PETER AND I SHARE THE SAME ADDRESS OVER EL VINO'S THE FAMOUS WINE BAR IN FLEET STREET — BUT THAT'S NOT THE REASON HE'S IN THIS BOOK, HE'S PROBABLY THE BEST STRIP CARTOON ADVENTURE WRITER IN THE BUSINESS. EACH MODESTY BLAISE STORY RUNS FOR ABOUT 20 WEEKS — THAT'S 100 STRIPS PLUS 20 EXTRA STRIPS FOR SYNDICATION (SOME PAPERS RUN SIX DAYS A WEEK.) PETER STARTS BY WORKING OUT A STORY CONCENTRATING ON THE MAIN IDEA FOR THE PLOT UNTIL THE STORY STARTS TO TAKE SHAPE — THE PLACE, THE THEME, THE CHARACTERS ETC. EACH STORY WILL TAKE ABOUT THREE WEEKS TO WRITE USING ABOUT 3 MAIN CHARACTERS BESIDES MODESTY TO GIVE THE STORY THE RIGHT BALANCE — ANY MORE AND IT GETS TOO COMPLICATED.

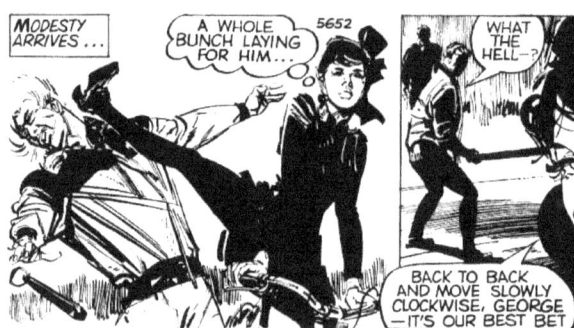

DAY ONE

1. Title Frame. The title is PLATO'S REPUBLIC. Here we are looking through a key-hole set in a wrought iron escutcheon on an ancient door. The whole frame is taken up by the escutcheon so this huge key-hole presents us with a view through it, and across the small cell we see head and shoulders of Modesty as she lies on her back on a bunk, hands behind her head. She wears a white rollneck sweater.

2. Panel: On the small island of Voulakis,
 in the Aegean.

Here we have a scene of several monks working in a vegetable garden a little way from monastry wall in background, hoeing, digging, etc. Between the monks and wall stand the two figures of Plato and Melinda, side by side. He is elegantly dressed in smart slacks, short-sleeved shirt and cravat, with cigarette in holder. She is in a blouse and skirt, a jacket over her arm. They are looking towards the monks. Cedric approaching.

 Plato: A charming scene ... so uplifting
 to one's soul.

3. Close shot of Plato and Melinda facing us. Beyond them is one of the arched entrances to the monastery, a monk carrying in a sack of something. Plato is amused. Melinda hates him.

 Melinda: Soul? You have no soul, Plato ...
 I wonder you are not struck dead
 for such talk.

* PETER O'DONNELL'S DRAWING.

AT THIS STAGE THE SCRIPT IS ABOUT FOUR OR FIVE PAGES LONG AND THIS IS GRADUALLY CONDENSED DOWN TO 1½ PAGES BY THE TIME IT GOES TO THE SCRIPT EDITOR TO BE READ. WHEN THE ARTIST GETS THE FINAL SCRIPT IT HAS BEEN CAREFULLY WORDED INTO SPEECH BALLOONS PLUS ANY SPECIAL REFERENCE NOTED AT THE FOOT OF EACH PAGE...

JIM HOLDAWAY WAS THE FIRST ARTIST TO DRAW THE STRIP UNTIL HIS DEATH IN 1970 — A SPANISH ARTIST CALLED ROMERO WAS NEXT UNTIL 1978 (THE SCRIPT WAS TRANSLATED AND SENT TO SPAIN, PETER ONLY EVER MET HIM ONCE). JOHN BURNS FOLLOWED FROM 1978/79 AND FINALLY NEVILLE COLVIN ———

USING THIS SYSTEM ALLOWS PETER TO PLAN OUT THE WHOLE TWENTY WEEKS WITH AN OPPORTUNITY TO ALTER OR IMPROVE AS HE GOES.

BY WORKING THIS WAY HE ALSO KEEPS SIX MONTHS AHEAD OF HIS ARTIST.

Smythe

ANDY CAPP'S CREATOR NORMALLY DRAWS AT HIS HOME IN THE NORTH OF ENGLAND SITTING IN A COMFORTABLE CHAIR IN HIS LOUNGE SLAP IN FRONT OF HIS TELEVISION. (SO AS NOT TO INTERRUPT HIS SOCIAL LIFE). NO FANCY STUDIOS OR DRAWING BOARDS FOR HIM.
REG SMYTHE THINKS UP THE IDEAS FIRST, THEN WORKS OUT THE SCRIPT AND FINALLY DIVIDES IT UP BETWEEN FRAMES, MORE SPEECH IN ONE FRAME, LESS IN THE NEXT, THIS IS TO MAKE SURE OF A GOOD BALANCE. FOR THE FINISHED ARTWORK HE USES AN OSMIROID LEFT HANDED PEN — HE IS LEFT HANDED AND IT TAKES FAR TOO LONG TO WEAR IN A RIGHT HANDED NIB. HE USES A BROADER NIB FOR THE LETTERING. THIS HE DOES HIMSELF TO MAKE SURE IT CAN BE EASILY READ —— MOST IMPORTANT IN A STRIP CARTOON...

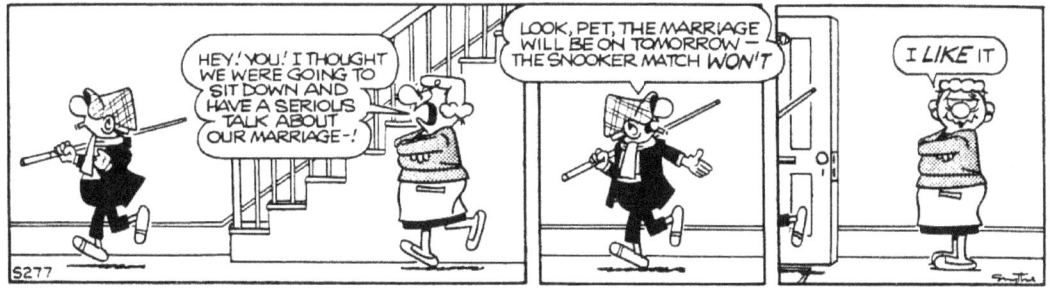

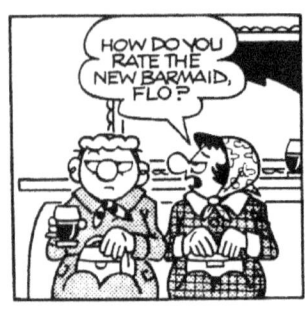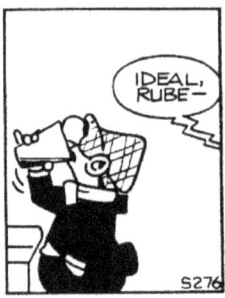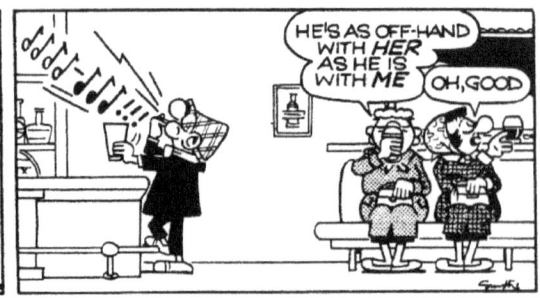

THE ARTWORK IS DRAWN ON DALER TRIMLINE BOARD. HE USES A CARDBOARD TEMPLATE AS A FRAME (BEING SYNDICATED IN 937 AMERICAN NEWSPAPERS HE HAS TO FOLLOW A SET RULE) ONE, TWO, THREE OR FOUR FRAMES TO SUIT THE GAG. REG SMYTHE WORKS ON TUESDAYS, WEDNESDAYS, THURSDAYS, SATURDAYS & SUNDAYS DRAWING SEVEN STRIPS PER WEEK, SIX FOR THE DAILY AND ONE FOR THE SUNDAY MIRROR PLUS WHATEVER IS REQUIRED FOR THE USA. EACH STRIP TAKES ABOUT ONE HOUR TO DRAW. HE IS A METICULOUS WORKER — NOT A MARK NOR A BLOT MUST BE SEEN — THEY LEAVE HIS HANDS AS IF TO HANG IN A GALLERY. REG NEVER THOUGHT THAT ANDY CAPP WITH HIS FLAT CAP, AND CIGARETTE HANGING FROM HIS MOUTH (THE TYPICAL NORTHERNER) WOULD HAVE SUCH UNIVERSAL APPEAL (HE SELLS IN 48 COUNTRIES) — 1,205 NEWSPAPERS WORLDWIDE AND IS READ BY 250 MILLION READERS. THE NAME ANDY CAPP CAME ABOUT WITH CAPP BEING THE OBVIOUS CHOICE AND ANDY BEING A USEFUL NAME TO GO WITH IT.

THAT'S 'ANDY

ANDY WAS ACTUALLY BASED ON A REAL LIFE PERSON — BUT REG SMYTHE IS NOT GOING TO SAY WHO; HOWEVER FLORRIE (OR FLO) GOT HER NAME FROM HIS MOTHER. ←
OVER THE YEARS ANDY HAS AGED A LITTLE AND HAS BECOME MORE DEPENDENT ON FLO (HE'S ALSO A LITTLE SQUATTER THAN HE USED TO BE HIS LEGS ARE SHORTER AND HE'S PUT ON A LITTLE WEIGHT (HAVEN'T WE ALL?) THERE IS ONE MAJOR PROBLEM WITH THE CHARACTER — HE CAN NEVER TAKE HIS HAT OFF ← ONLY ONCE DID HE EVER APPEAR WITHOUT HIS CAP (HE WAS IN BED AND IN THE LAST FRAME FLO SHOUTS —
"YOU CAN GET UP NOW, YOUR CAP'S BEEN HANDED IN").

LONG MAY YOU REIGN, ANDY.

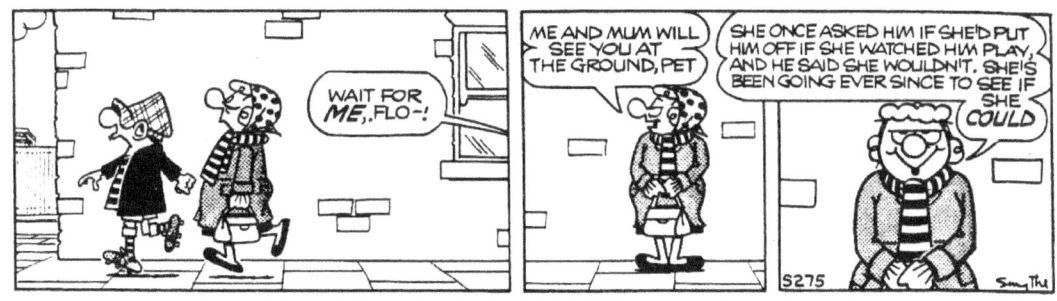

Posy Simmonds

THE BUSIER POSY IS, THE EASIER IT IS FOR HER TO MEET DEADLINES, SHE SAID — BECAUSE AS WELL AS DRAWING A WEEKLY CARTOON STRIP FOR THE GUARDIAN (SINCE 1977) SHE HAS ILLUSTRATED TWO BOOKS AND WRITTEN A FILM SCRIPT DURING THE LAST YEAR. HER WEEK BEGINS ON THURSDAY AFTERNOON AFTER SHE HAS DELIVERED THE WEEKLY CARTOON STRIP. ———— SHE THEN CLEARS HER DESK...

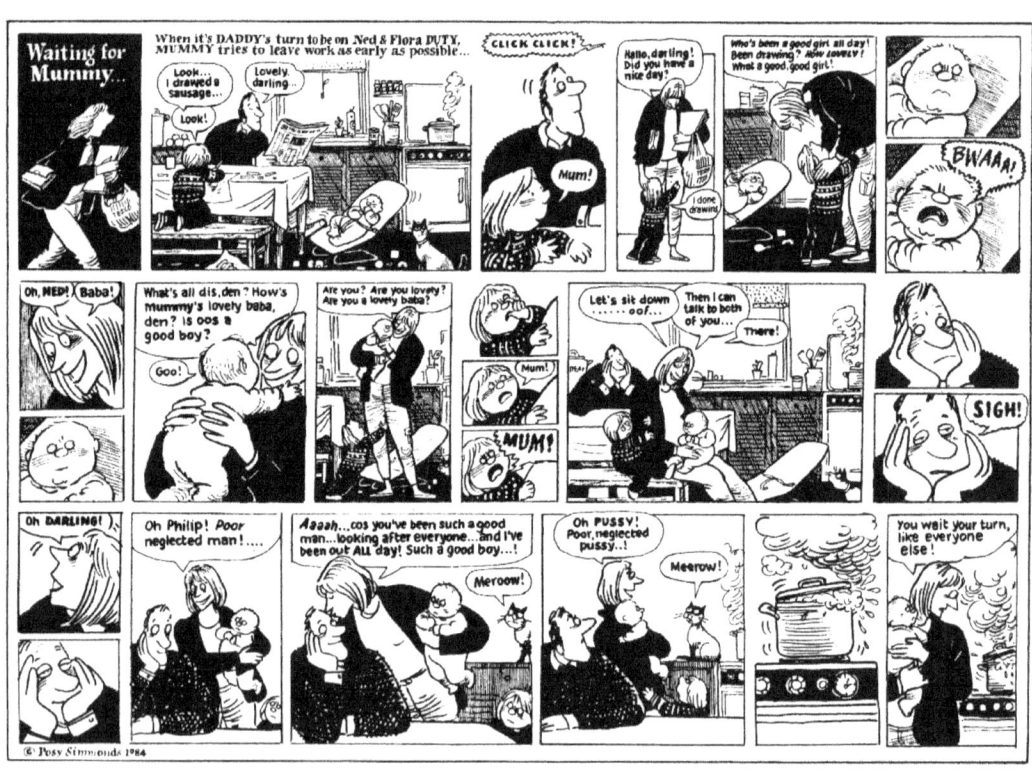

AND GETS READY TO START ALL OVER AGAIN ON NEXT WEEK'S STRIP —— ALTHOUGH SHE HAS NOW IMPROVED HER TIMING SO THAT SHE DOESN'T ACTUALLY START DRAWING UNTIL THE FOLLOWING TUESDAY (FOR THE THURSDAY DEADLINE) IN REALITY POSY IS WORKING ALL THE TIME, LISTENING, JOTTING DOWN SNIPPETS OF CONVERSATION, MAKING NOTES, DRAWING ITEMS OF CLOTHING, LITTLE MANNERISMS ETC. SO THAT BY TUESDAY SHE CAN START TO WORK ON A4 LAYOUT PAPER PLANNING THE STORYLINE AND DOODLING —— ON WEDNESDAY SHE MOVES UP TO A2 LAYOUT PAPER AND DRAWS THE FRAME IN PENCIL, THEN INKS IN FRAME ROUND THE BOX, THEN THE TITLE FRAME, THEN THE FIRST STORY FRAME (THIS IS HER WORST MOMENT)

Having prepared everything, frame, titles, panels — this little voice in her head says, it's up to you now, you've got to get it right from now on — she always does of course, but this is always a moment of panic.

On Wednesday Posy works all day at her drawing — sometimes until ten o'clock at night — sets her alarm for six the following morning and works on in her dressing gown until she has finished completely.

She delivers the drawing to the paper and needs six minutes to run from her home in Bloomsbury to the Guardian office to meet her noon deadline.

TWO, THREE, FOUR, FIVE...

POSY ALWAYS USES LAYOUT PAPER (SEMI-TRANSPARENT) FOR SAFETY SAKE BECAUSE SHOULD SHE EVER MAKE A MISTAKE SHE CAN TRACE AND CORRECT.

SHE DRAWS WITH A Nº3 RAPIDOGRAPH AND ROTRING INK, THE SOLID BLACKS ARE DONE WITH A PENTEL PEN — USING A DIP PEN FOR THE WHITE LETTERING — AND A '**FAT**' PEN FOR SPOKEN TEXT AND NARRATIVE —

THE BASTARDISED TYPEFACE IS CALLED 'ANAL RETENTIVE' AND POSY HAS BECOME VERY FAST AT DOING THIS OVER THE YEARS.

HER DRAWING BOARD IS A PIECE OF WOOD PROPPED UP AT THE BACK ON TWO BOOKS WITH A LARGE MIRROR ON THE WALL FACING HER THAT SHE USES FOR EXPRESSIONS, MANNERISMS AND GESTICULATIONS.

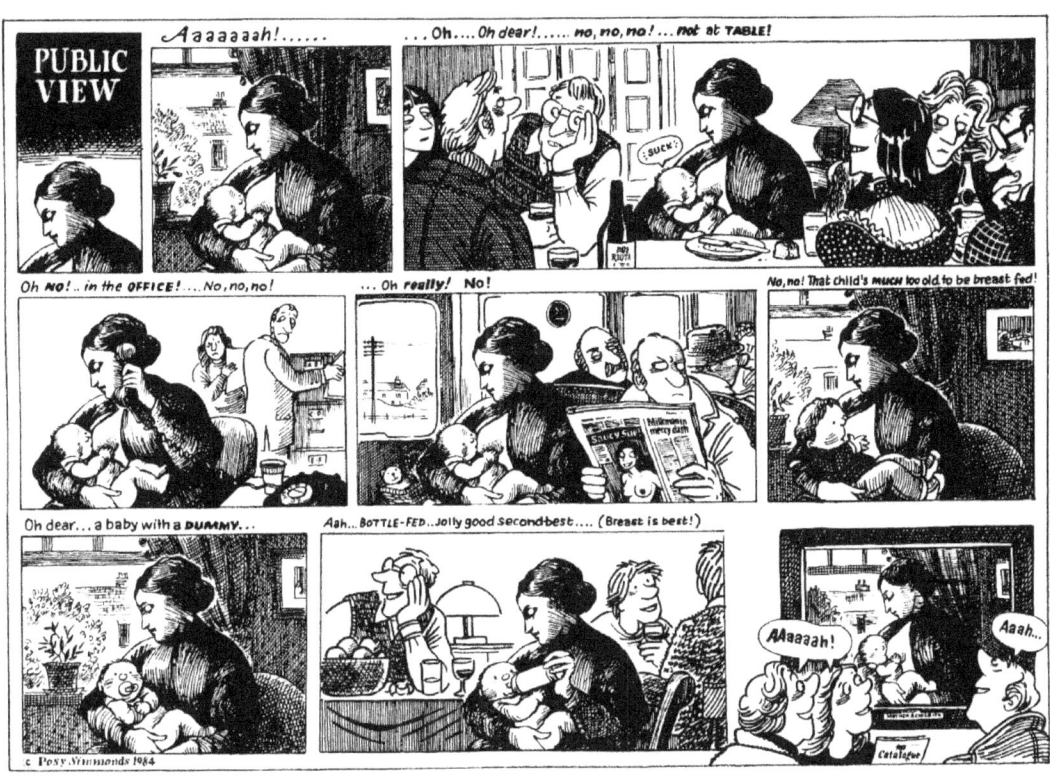

SHE USES HER LOCAL LIBRARY FOR REFERENCE BECAUSE GUARDIAN READERS ARE VERY CRITICAL.

SO EVERYTHING HAS TO BE ACCURATE, SHE SAID.

Peter Brookes

Until eighteen months ago Peter Brookes was a well known illustrator working for such magazines as the Radio Times, The Listener and various newspapers. When Lurie left 'The Times' he was offered the daily political cartoon spot— This is to produce 4/5 cartoons per week plus two feature cartoons.

He starts the day by listening to the 'Today' programme on his car radio as he drives to work from his home in Blackheath— On his arrival at the Times office, which he shares with Mel Calman, he reads all the daily papers washed down with umpteen cups of tea— So by the time the daily editorial meeting is called at 11·30 am. he has a basic idea of the important news of that day and has prepared one or two roughs in his tiny A6 sketchbook— He offers one idea at a time at the meeting— and when one is accepted he returns to his office to rough out the cartoon...

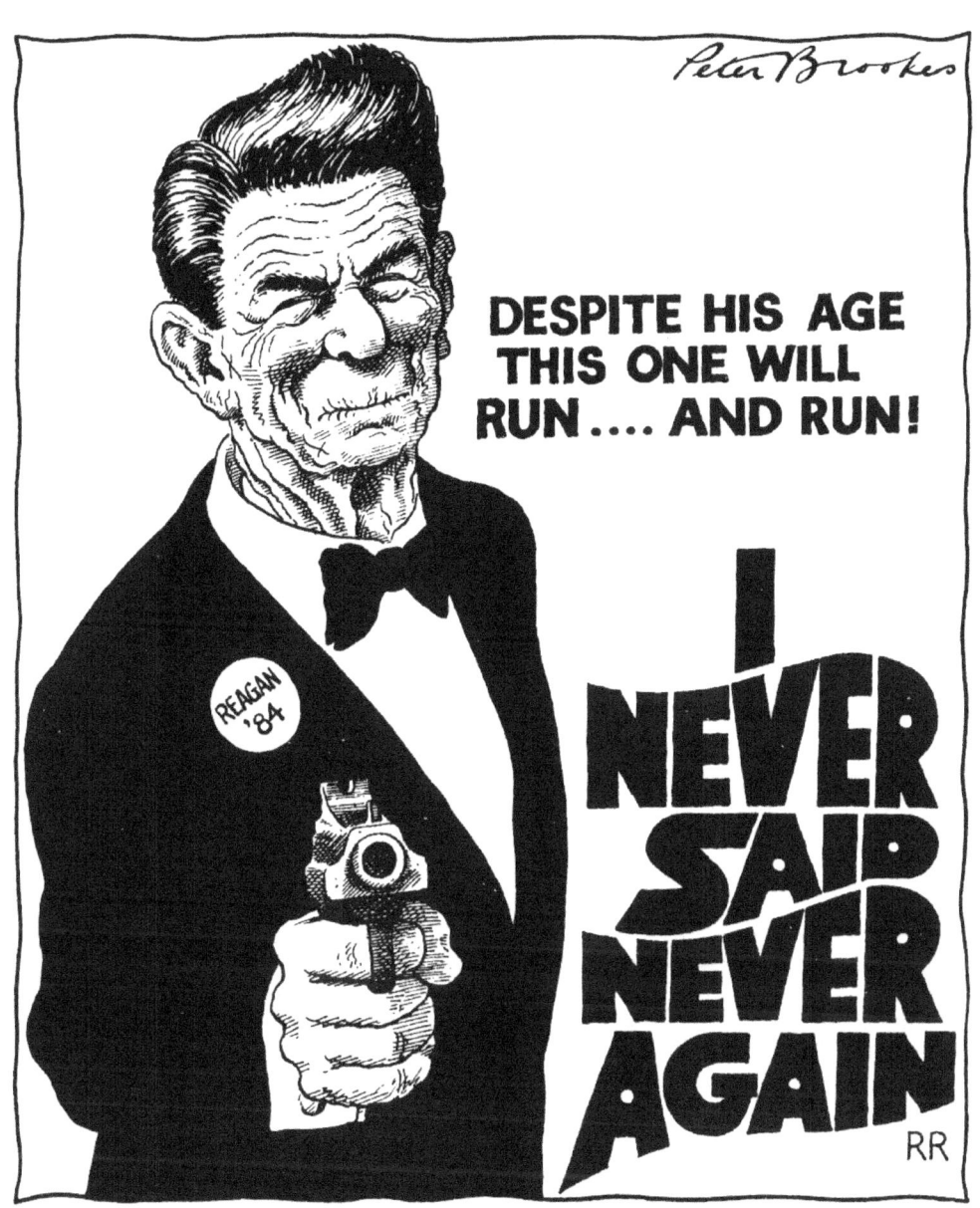

REAGAN ANNOUNCES HE WILL RUN AGAIN

HE STOPS FOR LUNCH, BUT STILL LISTENS TO RADIO'S WORLD AT ONE — AFTER LUNCH HE STARTS WORK ON THE FINISHED DRAWING USING A DIP PEN, EITHER GILLOT 404, 303, OR 1950 NIB, PELIKAN BLACK INK AND SANDERS 90lb PAPER — UNFORTUNATELY NOW DISCONTINUED NOT SURPRISINGLY AS THE LAST PACK HE BOUGHT HAD BEEN SIZED ON THE WRONG SIDE.

HE WOULD LOVE TO WORK AT HOME WHERE HE HAS HUNDREDS OF BOOKS FOR REFERENCE — BUT THE TIMES HAVE MORE READILY AVAILABLE MATERIAL AT HAND SO HE WORKS THERE.

EACH DRAWING CAN TAKE ANYTHING BETWEEN TWO OR FOUR HOURS TO PRODUCE — HE WORKS ON UNTIL 7·30 PM OR SO STAYING AT THE PAPER UNTIL THE FIRST EDITION IS PUT TO BED.

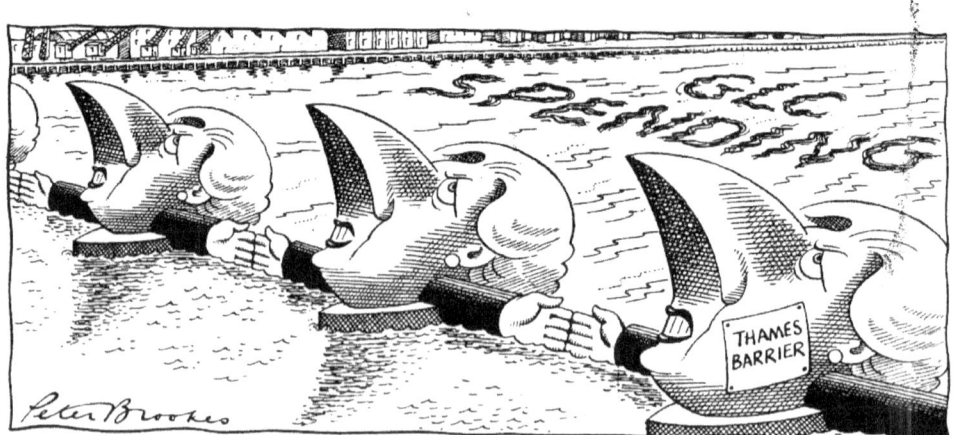

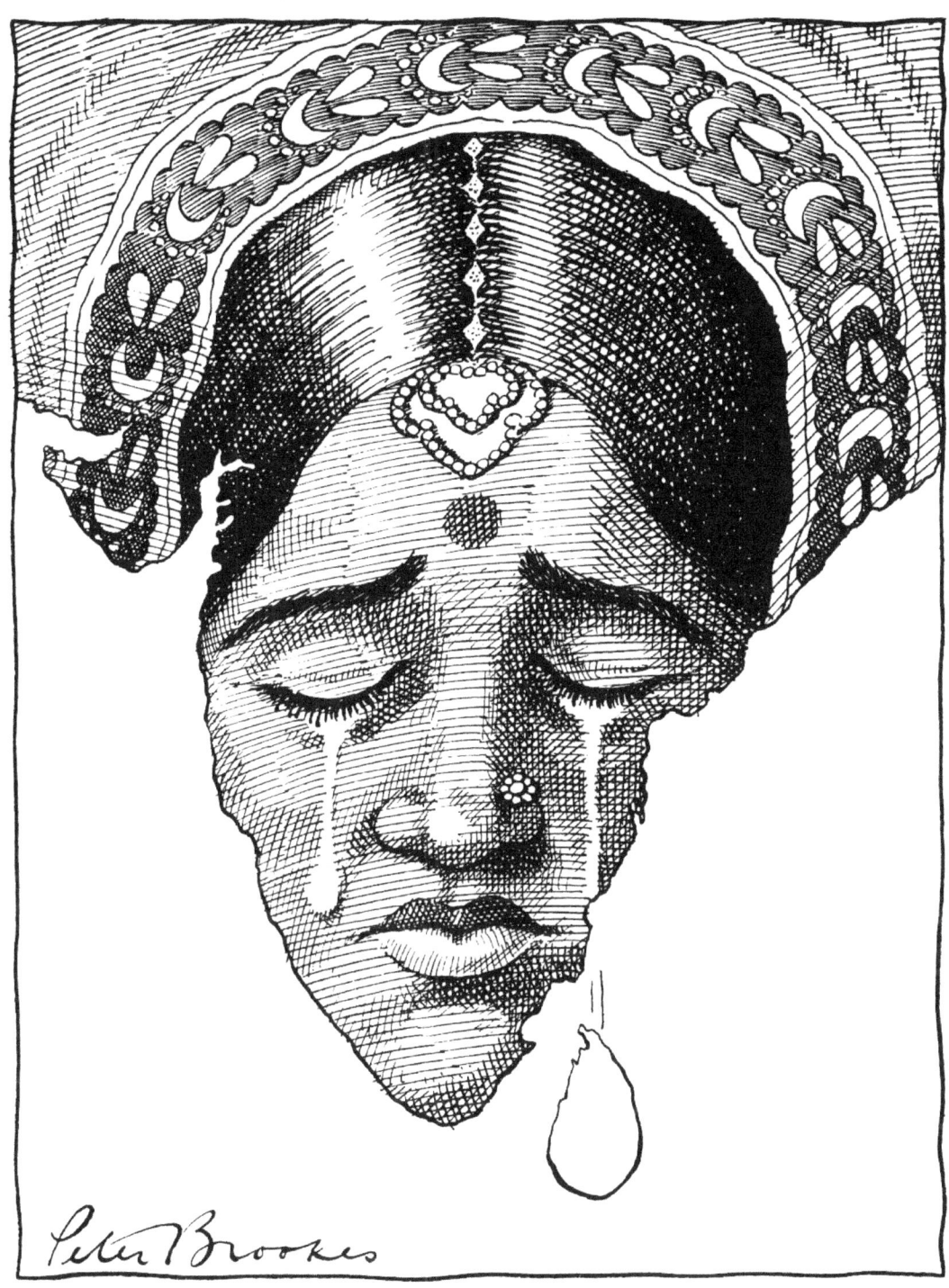

MASSACRES & RIOTS IN SRI LANKA

John Glashan

I MET JOHN GLASHAN IN HIS HAMPSTEAD FLAT SURROUNDED BY HIS BEAUTIFUL WATERCOLOURS. THIS IS HIS HOME AND HIS STUDIO AND HE IS AS WELL KNOWN AS A PAINTER AND AN ILLUSTRATOR AS HE IS A CARTOONIST — HE DID THE STUNNING ANODE ENZYME CARTOONS IN THE OBSERVER COLOUR MAGAZINE UNTIL RECENTLY, BUT HE NO LONGER DOES A REGULAR DAILY/WEEKLY CARTOON.

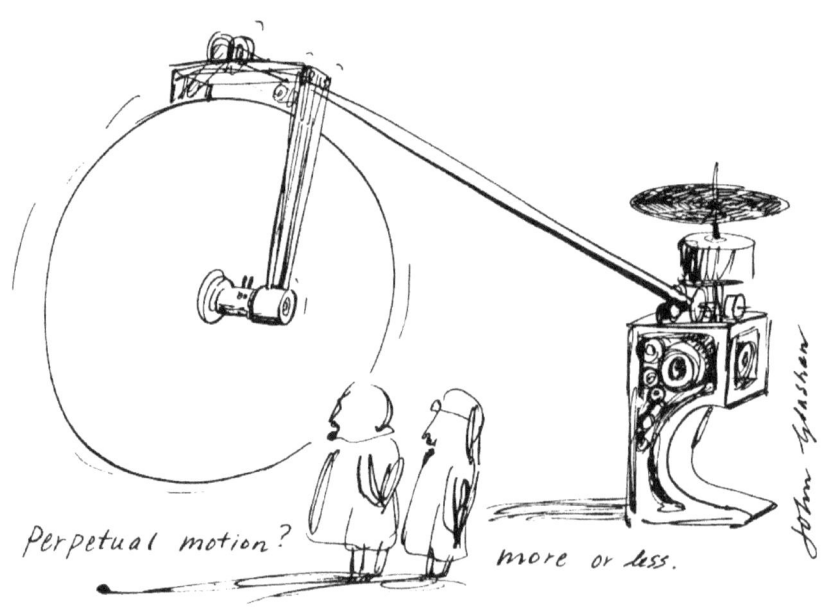

Perpetual motion? more or less.

HE DRAWS AT HIS DRAWING BOARD, ON A TABLE OR ON HIS LAP —— HE'S NOT FUSSY, USING ANY OLD A4 TYPING PAPER, HE'S NOT LOYAL TO ANY PARTICULAR BRAND.
HE LIKES TO USE A DIP PEN AND KEEPS BOXES OF NIBS OF VARYING SIZES TO CHOOSE FROM — ADDING WATERCOLOUR SOMETIMES TO ADD EXTRA DIMENSION TO HIS CARTOONS. HE DOESN'T DO ROUGHS BECAUSE HE LIKES TO GO STRAIGHT INTO THE FINISHED DRAWING —— THIS MAY MEAN AS MANY AS TWENTY VERSIONS OF THE SAME DRAWING, BUT HE FINALLY CHOOSES ONE HE LIKES BEST...

HE USED THE SAME TECHNIQUE FOR ANODE ENZYME — DRAWING AT GREAT SPEED, TEARING UP DRAWINGS THAT DIDN'T GO RIGHT, AND EVENTUALLY ENDING UP WITH ONE THAT GAVE HIM SATISFACTION.

JOHN McGLASHAN (TO USE HIS REAL NAME — HE ONLY USES GLASHAN FOR HIS CARTOONS AND ILLUSTRATIONS) TRAINED AS A PAINTER AT GLASGOW SCHOOL OF ART BUT TURNED TO CARTOONING TO MAKE A LIVING. HE SAID ONE CAN'T REALLY MAKE A LIVING FROM PAINTING BECAUSE THE MEDIA CAN ONLY COPE WITH THREE ARTISTS AT A TIME — THE GRAND OLD MAN, THE MIDDLE MAN AND THE UP AND COMING MAN...

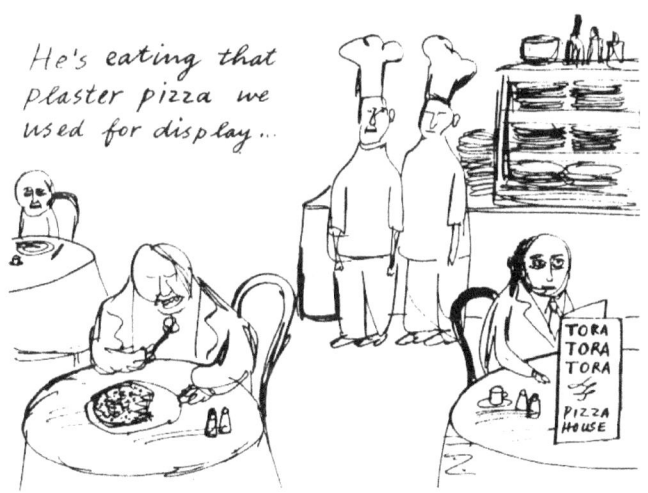

Cummings

Michael Cummings gets up each day at 7.0 AM and turns on Radio 4 to listen to the news (political cartoonists always listen to the news) as he values his breakfast and hates the horrors of humanity. He leaves the papers to read until after he's eaten ——

He reads ALL the papers, especially the Daily Express mainly to see what other cartoonists are doing — just in case they should clash on subject matter...

He leaves for work around 9.30 AM and thinks about ideas during his journey and on reaching his office at the Daily Express — by 10 o'clock he's discussed the leader and has read the news schedule.

Having worked out 5 or 6 ideas which he roughs out on layout paper (A3 pad) in pencil — it's into the editor's office where they decide on the idea for the day. ➡

ONCE THE CARTOON HAS BEEN DECIDED UPON —— IT'S DOWN TO WORK BETWEEN NOON AND FOUR. THE CARTOON IS ROUGHED OUT IN PENCIL ON DALER BOARD (HE USED TO USE CARTRIDGE PAPER BUT NOW PREFERS A HALF IMPERIAL SIZE BOARD) — A DIP PEN WITH A FINE NIB FOR LETTERING, LOTS OF PELIKAN INK — HE DOES A SMALL AMOUNT OF DRAWING WITH A BRUSH, (THIS SURPRISED ME BECAUSE HIS BOLD STYLE LOOKS AS IF HE USES A BRUSH ALL THE TIME). HE USES WINSOR & NEWTON ULTRAMARINE FOR TONE DRAWING.

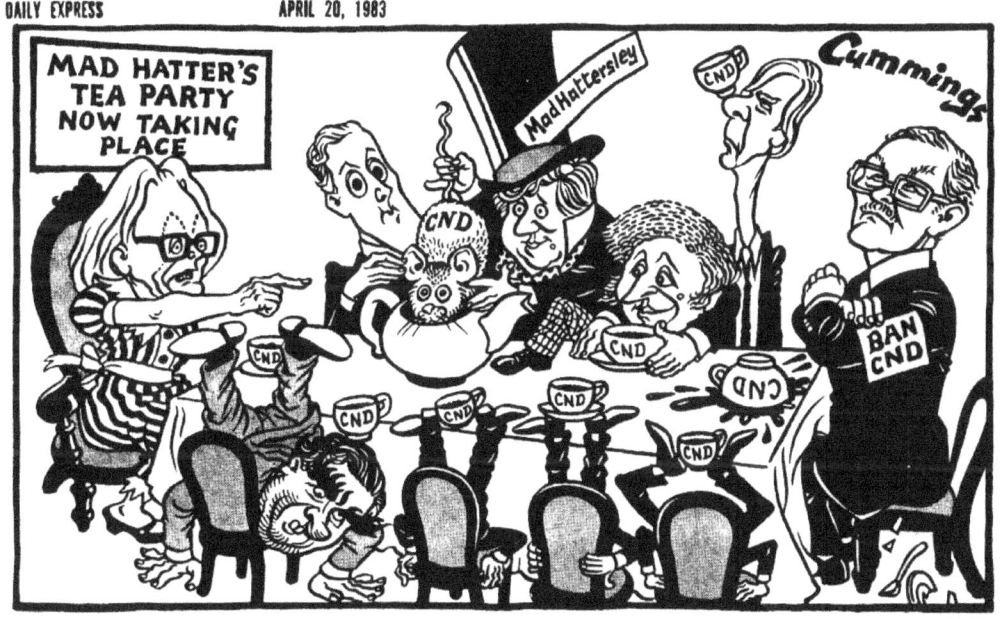

"Leave the tea party, Mr Duffy! You're suffering from a dangerous outbreak of sanity..."

CUMMINGS ALWAYS WORKS ON A DESK WITH THE EXCEPTION OF THOSE LONG NARROW DRAWINGS, THEN HE WORKS ON HIS LAP. HE FINDS GOING OUT TO LUNCH DISTURBS HIS CONCENTRATION — SO IT'S A SANDWICH & COFFEE FOR 15 MINUTES BREAK THEN BACK TO THE DRAWING BOARD. HE LIKES SOLITUDE WHILE HE'S WORKING — NO RADIO, T.V. OR EVEN TALKING WHILE I'M WORKING THANK YOU VERY MUCH, HE SAID.

DAILY EXPRESS MARCH 30, 1984

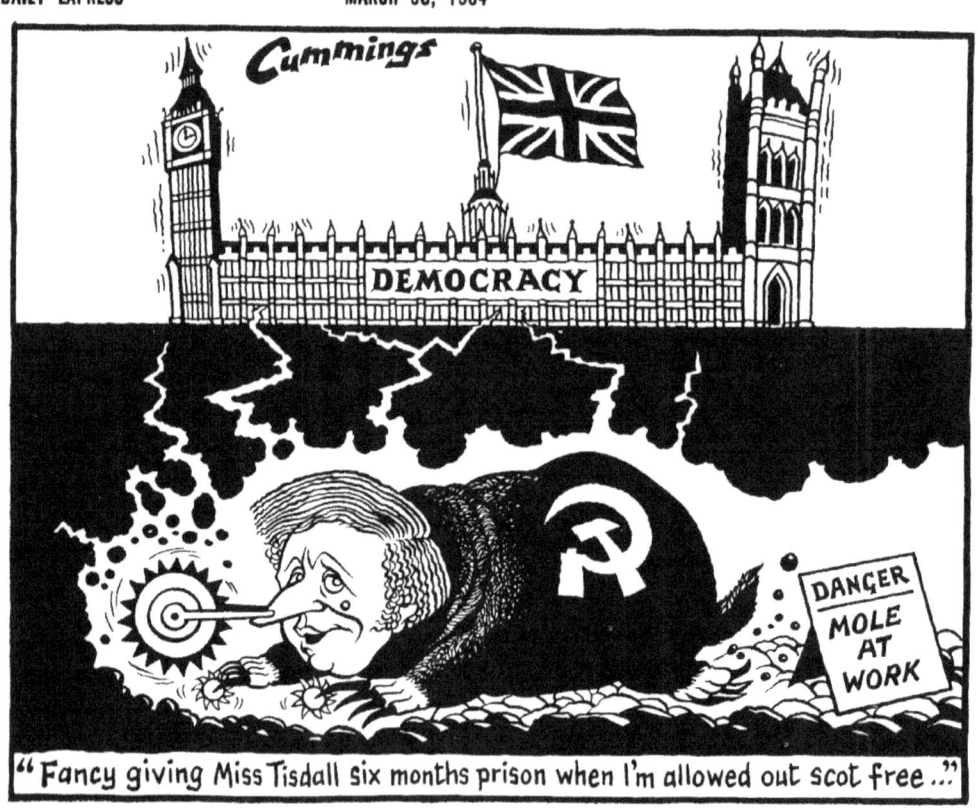

"Fancy giving Miss Tisdall six months prison when I'm allowed out scot free..."

DAILY EXPRESS 1 JULY, 1983

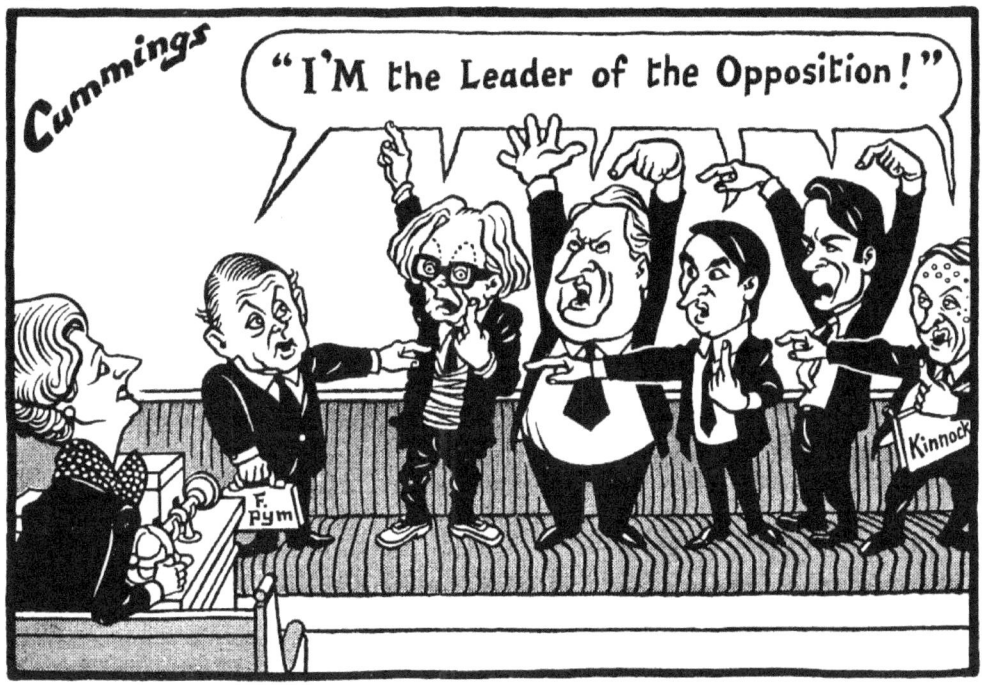

THE FINISHED CARTOON IS READY BY SIX THIRTY P.M. (ON SATURDAYS FOR THE SUNDAY EXPRESS BY FOUR THIRTY).
MICHAEL CUMMINGS JOINED THE DAILY EXPRESS IN 1949. HE WENT TO CHELSEA SCHOOL OF ART AND SPECIALISED IN ETCHING — HE STARTED CARTOONING FOR MICHAEL FOOT, THEN EDITOR OF FORTUNE MAGAZINE, AND HE SAYS THAT BEING A CARTOONIST IS LIKE BEING A COOK —— HOURS OF PREPARATION —— AND IT'S GONE IN A MINUTE.

BILL TIDY WORKS IN HIS LARGE STUDIO OF FOUR (OR IS IT FIVE?) ROOMS ABOVE HIS WIFE'S FURNITURE RENOVATION SHOP IN SOUTHPORT (UP NORTH). HE ARRIVES AT 8·45 AM EACH DAY MONDAY TO FRIDAY HAVING ALREADY BEEN FOR A RUN (PUFF PUFF) OR USED HIS EXERCISE BIKE — HE'S DONE THIS FOR THE LAST TWENTY YEARS.

HE NOW DOES FIVE REGULAR CARTOON STRIPS PER WEEK PLUS MANY SINGLE CARTOONS FOR PUNCH + ADVERTISING ETC...

HE DRAWS MAINLY ON CROXLEY A4 SCRIPT PAPER BUT SOMETIMES TREATS HIMSELF TO A LARGER SIZE IF HE'S FEELING AMBITIOUS.

USING AN ORDINARY DIP PEN WITH A GILLOT 303 NIB AND PELIKAN INK HE WORKS OUT A COUPLE OF ROUGHS — THEN INTO THE FINISHED DRAWINGS WHICH TAKE HIM AROUND TEN MINUTES...

'NO, IT ISN'T DOING MY PILES ANY GOOD EITHER'

ALTHOUGH HE LIKES CARTOONING HE HAS BEGUN TO FEEL LATELY THAT IT IS NOT ENOUGH, HE FEELS THAT CARTOONING IS THE LOWEST OF ALL THE ARTS AND IT DOESN'T EARN MUCH RESPECT. HE LOVES MAGIC MARKERS AND SAYS HE COULD HAVE PAINTED THE SISTINE CHAPEL IF HE COULD HAVE DONE IT WITH MAGIC MARKERS — HE DOESN'T THINK MUCH ABOUT HIS DRAWING STYLE ANY MORE THAN HE THINKS THAT HE WALKS LIKE ROBERT MITCHUM ——————— BUT HE DOES ADMIT TO BEING INFLUENCED BY THE LATE ERIC BERGIN AND THE EARLY RONALD SEARLE — AND HE DID ONCE TRY DRAWING CARTOONS FOR RADIO — BUT THEY MADE HIM USE SQUEAKY CHALK.

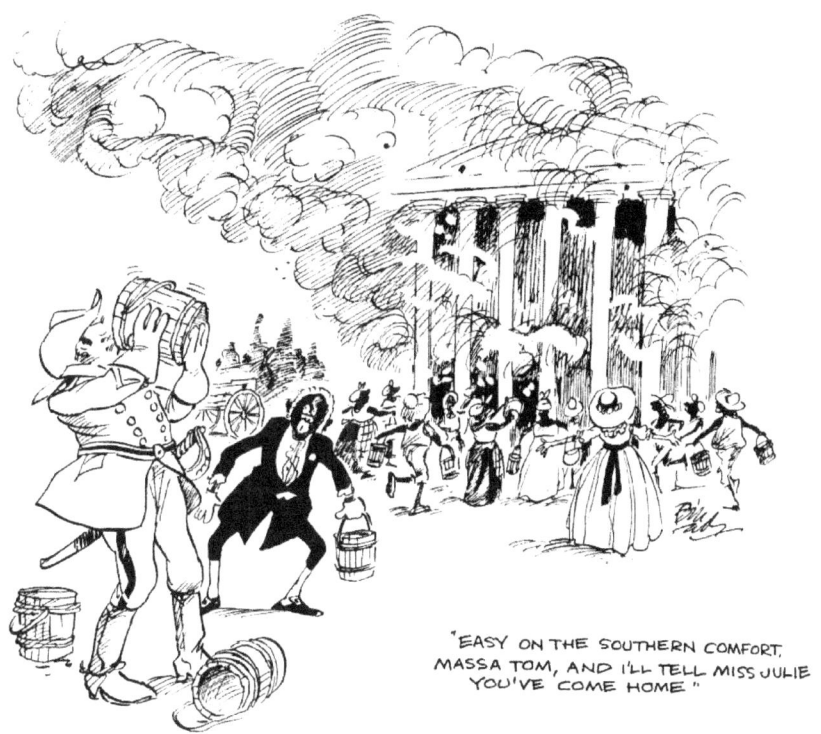

"EASY ON THE SOUTHERN COMFORT, MASSA TOM, AND I'LL TELL MISS JULIE YOU'VE COME HOME."

FRANKLIN

Stanley Franklin's day starts at 7am listening to the radio news and reading the newspapers —— this he has done every working day since joining the Sun newspaper in 1974 as their political cartoonist.

He likes to arrive at his desk around 11am each morning with one or two ideas already worked out in his head so that he can start work on his roughs immediately on arrival.

Franklin draws with a mapping pen, including his roughs, taking two or three of these into the editor for the final choice.

The finished drawing is one third up on printed size, drawn on Bristol board and takes about three hours to produce.

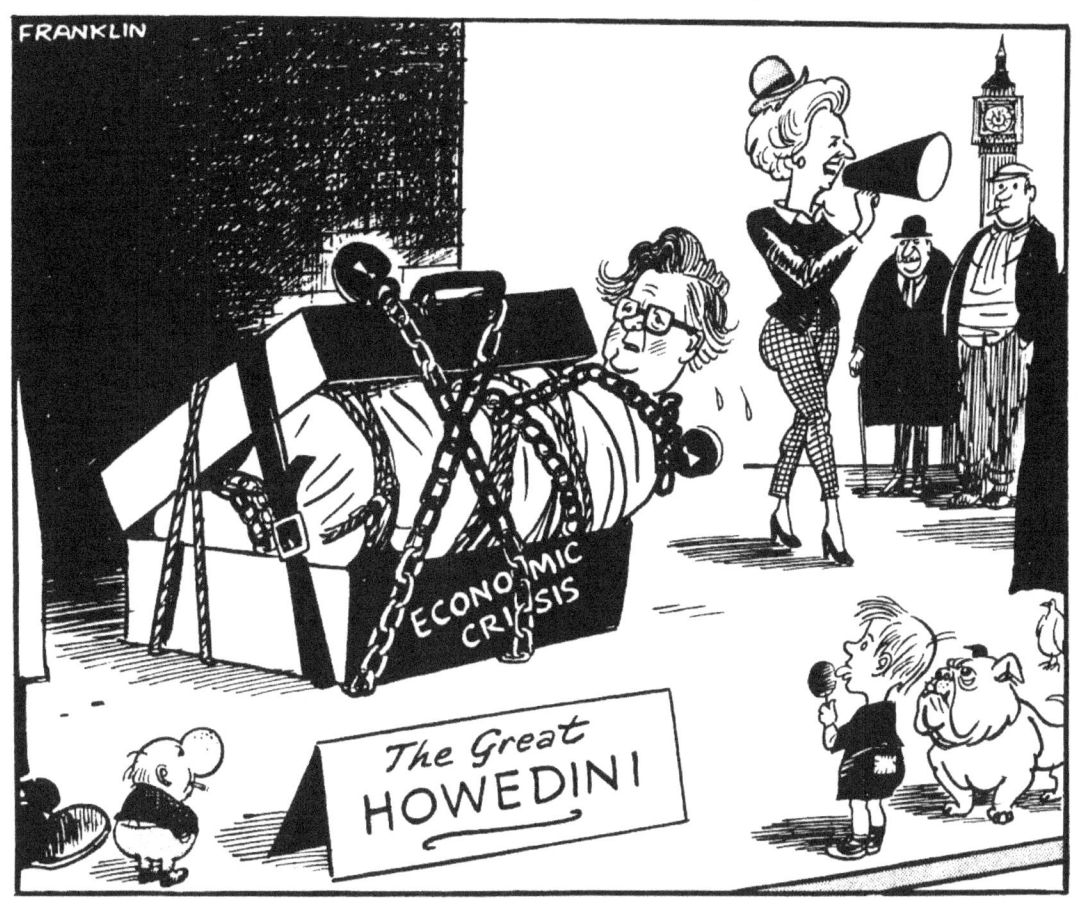

"DON'T MISS THE ESCAPE OF THE CENTURY..."

WHENEVER YOU SEE A FRANKLIN CARTOON — LOOK FOR THE LITTLE MAN STANDING BY AND LOOKING ON, RASPBERRY IS HIS NAME, ON ACCOUNT OF HIS SPOTTY NOSE.

IT ALL STARTED A LONG TIME AGO WHEN FRANKLIN WAS IN ADVERTISING — HE USED TO DRAW THIS LITTLE MAN ON GREETINGS CARDS TO HIS FRIENDS AND EVENTUALLY IT BECAME A HABIT — PART OF HIS SIGNATURE.

 WHEN HE JOINED THE DAILY MIRROR AS THEIR POLITICAL CARTOONIST IN 1959 THE LITTLE MAN APPEARED REGULARLY AS PART OF THE ONLOOKING CROWD—

SO THAT WHEN HE TOOK OVER FROM RIGBY THE AUSTRALIAN CARTOONIST WHO ALWAYS HAD A LITTLE MAN AND HIS DOG IN HIS **SUN** CARTOONS — FRANKLIN INTRODUCED RASPBERRY TO HIS READERS AND INSTEAD OF A DOG — LOOK AROUND FOR A PIGEON, IT'S USUALLY THERE SOMEWHERE...

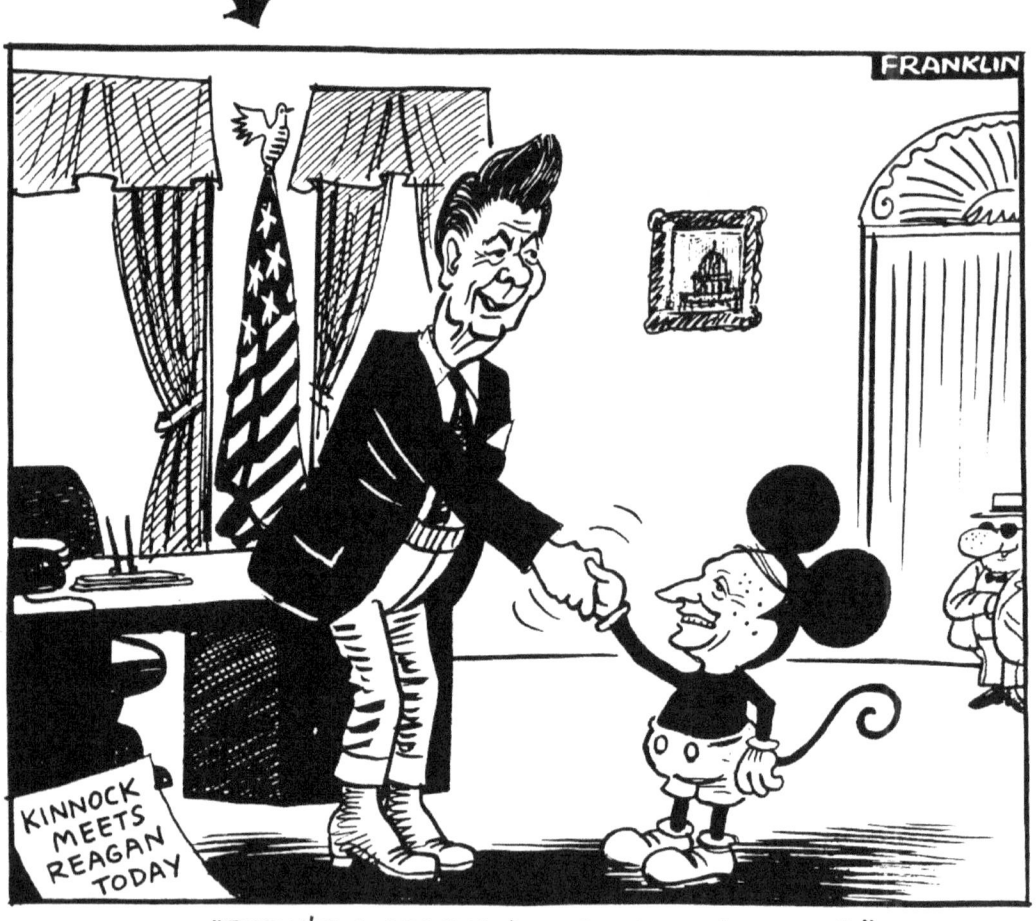

"DIDN'T I KNOW YOU IN HOLLYWOOD?"

HEATH

Michael Heath's week is very much at the double, it has to be because he's always on the move. He used to work from his home in Brighton but after ten years decided he needed the stimulus of Fleet Street and meeting people, and besides—"The postal system no longer works."

On Mondays he starts at London's Standard newspaper around 10am and leaves 3 or 4 roughs for the editor to choose for the following day's cartoon—— then it's on to Punch magazine where he works on several cartoon ideas or any special spread they may require —— then it's on to Private Eye to meet Richard Ingrams...

"I DO BEG YOUR PARDON, IT'S JUST THAT YOU REMINDED ME OF SOMEONE ELSE"

WEDNESDAY, AGAIN TO THE STANDARD THEN ON TO THE GUARDIAN TO DO HIS 'BABY' STRIP CARTOON —— THURSDAY TO THE STANDARD AND THEN TO THE SUNDAY TIMES TO DO VARIOUS DRAWINGS (HE'S GIVEN A SET SIZE FOR THESE AND IT'S THEN UP TO HIM TO PRODUCE WITTY GAGS TO FIT THE EDITORIAL CONTENT.) HE RETURNS TO THE SUNDAY TIMES ON FRIDAY AFTERNOON AFTER HIS DAILY VISIT TO THE STANDARD TO FINISH OFF HIS BITS & PIECES AND THEN WORK ON HIS FRONT PAGE CARTOON.
MICHAEL DRAWS ON THE CHEAPEST TYPING PAPER WITH ANY PEN THAT IS AT HAND —— DIP PEN, FIBRE TIP, FOUNTAIN PEN, ROLLER BALL, HE'S NOT FUSSY. HE LOVES NOISE AND INTERRUPTIONS WHILE HE'S WORKING —— HE DRAWS DIRECT ON TO PAPER IN INK —— NO PENCIL, 1/3 RD UP IN SIZE AND HE NEVER USES TINTS.

I'VE BEEN WATCHING HIM FOR TWO HOURS — I CAN'T TELL IF HE'S ON STRIKE OR NOT.

30 OR 40 OF MICHAEL HEATH'S DRAWINGS ARE PUBLISHED EVERY WEEK — BUT THIS CAN MEAN THAT HE HAS ACTUALLY DRAWN 60 OR 65 BECAUSE NO FINAL DRAWING IS EVER THE SAME AS THE ROUGH ———— HE INSISTS THAT HIS DRAWING HAS CHANGED OVER THE YEARS — BUT HE'S NOT SURE HOW.

SOME BLOKE WAS IN HERE LAST NIGHT THROWING HIS MONEY ABOUT...

TO BE A SUCCESSFUL CARTOONIST YOU HAVE TO BE CONSTANTLY AWARE OF TRENDS, HE SAID — DRESS, WORDS, PLACES, YOU CAN NEVER LET UP BECAUSE IT'S ESSENTIAL TO BE ALWAYS TOPICAL.

SORRY LUV, I'M ALL OUT OF EMBRYOS

Garland

Nick Garland is the regular political cartoonist for the Daily Telegraph. He produces six cartoons each week, five for the daily and one for the Sunday. He also does the Spectator cover most weeks plus any small drawings for leader/feature articles.

He is usually in his office at the Telegraph by 1.0 pm. and claims that the actual journey into the office is a very important part of his working day—thinking time...

The practical reason for going to the office a 1.0pm is that the news is too weak in the morning, but it has a way of forming itself and by lunchtime it has settled down.—— And having read all the day's newspapers by the time the 3.45 editorial conference arrives, he need not take part but can sit back and listen to the discussion...

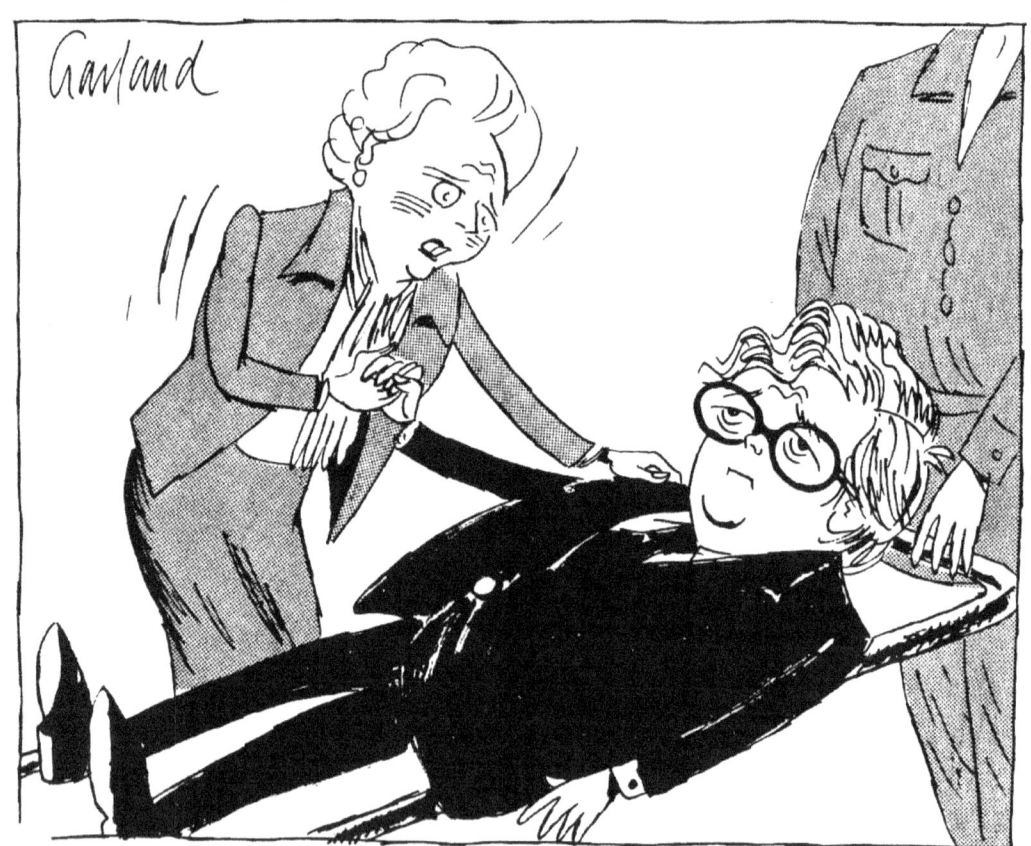

The Prime Minister greeting the wounded from Grenada.

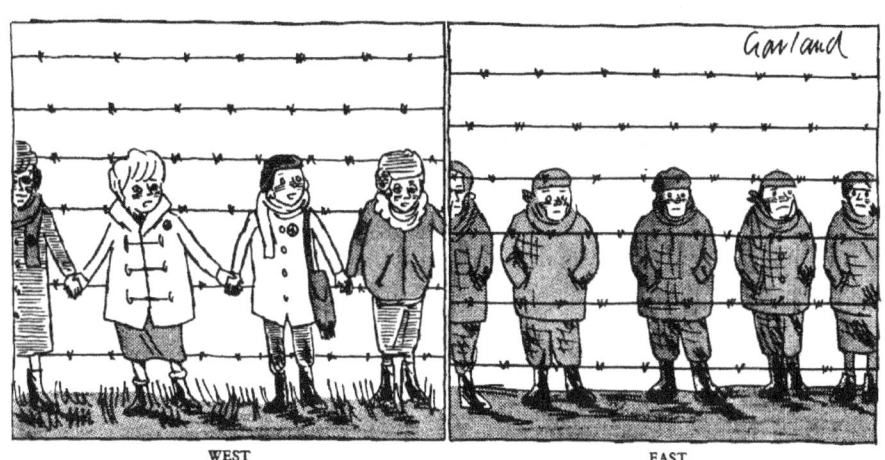

At 5pm he listens to the news — he says he rarely has the final idea even then (in the old days he would panic, but now the idea is like a mouse running the skirting board — he knows the hole is there somewhere.)

Nick doodles on bits of paper at his drawing board, re-arranging, adding, forming his idea, making the drawing clear until he is sure of his direction — he then uses an A4 layout pad to rough out the idea with a 3B pencil.

Then he works on Daler N.O.T wash & line board, mapping out the drawing in considerable detail in pencil, marking precisely where the ink drawing will go.

NICK GARLAND USES A SHEAFFER NO NONSENSE FOUNTAIN PEN — ONE WITH A FINE NIB AND ONE WITH A MEDIUM NIB. SHEAFFER CARTRIDGE INK AND INDIA INK WITH A BRUSH FOR FILLING IN. HE USES ROWNEYS PROCESS WHITE FOR CORRECTING MISTAKES. HIS ARTWORK TAKES ABOUT 1½ HOURS (BUT THIS CAN VARY ACCORDING TO CONTENT). HE IS USUALLY FINISHED AND READY TO LEAVE THE OFFICE BY SEVEN.

Larry

LARRY LIVES IN STRATFORD UPON AVON AND HE COMMUTES DAILY TO HIS STUDIO IN BIRMINGHAM. HE STARTS WORK ABOUT 11·0 AM AND WORKS UNTIL 5·30 PM STOPPING FOR A LUNCH TIME PINT — BUT IN REALITY HE WORKS ANY AMOUNT OF TIME NEEDED TO FINISH THE DAY'S WORK.

HE DRAWS ON A DRAWING BOARD PROPPED UP ON HIS DESK — BUT CAN JUST AS EASILY DRAW FLAT IF THE MOOD TAKES HIM OR EVEN ON HIS HIS LAP. LARRY USES ORDINARY 10" x 8" TYPING PAPER (ANY MAKE)

A ROLINX DIP PEN COSTING ABOUT 21P AND ROTRING BLACK INK. HE DRAWS DIRECT IN INK, NEVER IN PENCIL — THAT'S HOW TO KEEP THE SPONTANEITY ALIVE, HE SAID — YOU LOSE SO MUCH TRACING OVER THE PENCIL LINES.

SOMETIMES LARRY USES WATERCOLOUR. BUT AS THE MAIN DEMAND IS FOR CARTOONS IN BLACK & WHITE HE TURNS OUT 40 OR 50 OF THESE A WEEK.

HE'S NEVER SHORT OF IDEAS AND HAS NO FEAR OF EVER DRYING UP (HOW CAN YOU DRY UP WHEN YOU ENJOY WHAT YOU'RE DOING?) THEMES ARE A GREAT WAY OF CREATING IDEAS HE SAID, GIVE ME A GOOD THEME AND I'LL GIVE YOU A HUNDRED AND ONE GAGS, GARDEN GNOMES, SEASIDE HOLIDAYS, WALKING FRAMES, MODEL VILLAGES, SKYDIVING AND SO ON...

HE'S NOT A TOPICAL CARTOONIST SO HE CAN USE ANY IDEA THAT COMES TO MIND —— AT THE MOMENT HE'S INTO FINE ART IDEAS: RODIN GAGS AND FAMOUS PAINTING THEMES... ONCE HE HAS THE IDEA THE ACTUAL ARTWORK TAKES HIM ABOUT TEN MINUTES.

LARRY WENT TO SLADE ART SCHOOL AND
TAUGHT AT PETERBOROUGH SCHOOL OF ART
FOR THREE YEARS. HE AND I MET IN BIRMINGHAM
THIRTY YEARS AGO APPLYING FOR THE SAME JOB
AS A CARTOONIST; THEY EMPLOYED BOTH OF US AND
WE WORKED TOGETHER FOR A YEAR SO I WAS
GREATLY INFLUENCED BY LARRY AND I ADMIT
TO BEING HIS NUMBER ONE FAN. LARRY ADMIRES
DAUMIER, LAUTREC AND BOSCH, BUT THEN NONE
OF US IS PERFECT.

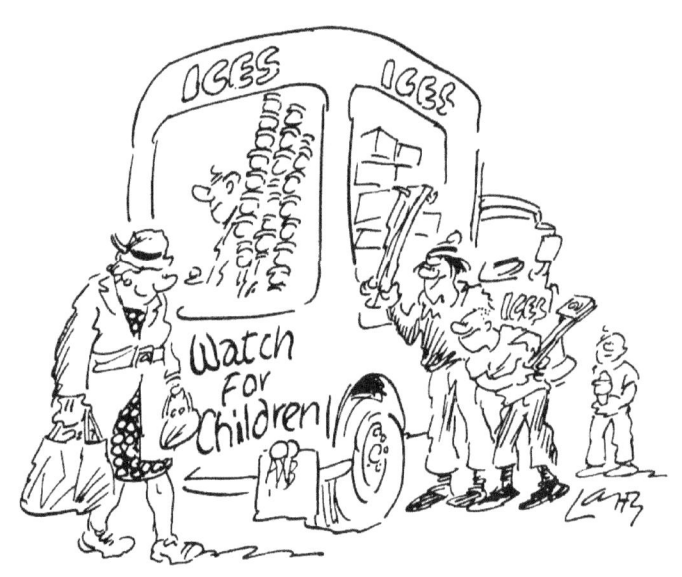

JOHN JENSEN CLAIMS TO BE THE MUCKIEST WORKER IN THE BUSINESS. HE SCRATCHES OUT BITS, ADDS PIECES, PATCHES, STICKS AND WHITES OUT ON ALL HIS CARTOONS. (IT CERTAINLY DOESN'T SHOW.) HE STARTS WORK AT 9 AM. EACH DAY SITTING ON A HIGH STOOL AT HIS DRAWING BOARD IN HIS TINY STUDIO AT HIS HOME SLAP IN THE HEART OF LONDON'S WEST END. ———————— FOR HIS BLACK AND WHITE DRAWINGS HE USES A2 LAYOUT PADS (THE FLIMSY SEMI-SEE THROUGH TYPE.) HE NEVER DRAWS ON BOARD BECAUSE HE LIKES TO BUILD UP HIS DRAWING LAYER BY LAYER, POSSIBLY ENDING UP WITH SIX LAYERS BEFORE HE GETS TO THE FINISHED DRAWING.

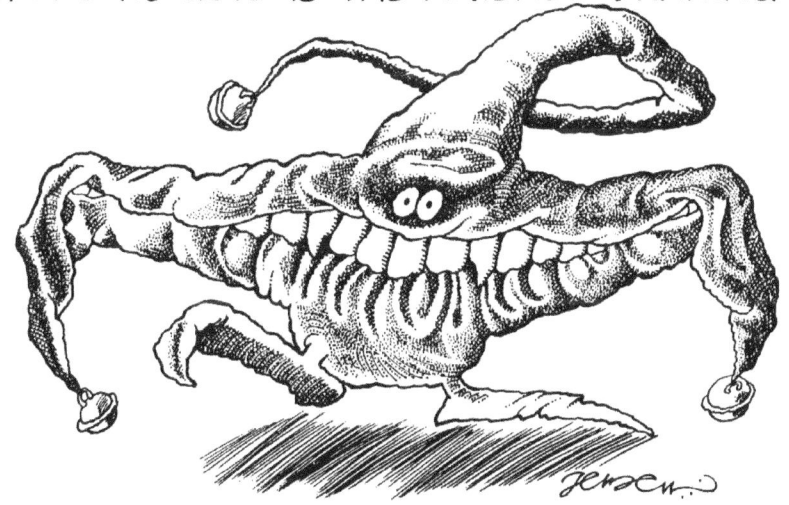

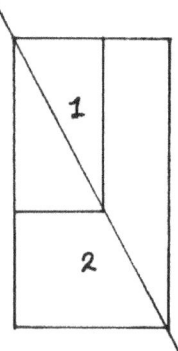

JENSEN LIKES TO DRAW TWO SIZES UP FROM PUBLICATION SIZE — HE USES THE OLD FASHIONED DIP PEN AND PELIKAN INK. A DRAWING LIKE THE ONE BELOW TAKES ABOUT TWO HOURS (PLUS BLOTCHES, PATCHES AND PROCESS WHITE).

HE HAS A LARGE COLLECTION OF NEW AND SECONDHAND BOOKS FOR REFERENCE PLUS A SPLENDID PHOTOGRAPHIC LIBRARY. FOR HIS COLOUR WORK HE USES THE BEST QUALITY WATER COLOUR PAPER (AROUND £20·00 PER PAD) AND WINSOR & NEWTON GOUACHE PAINTS.

IF HE IS SCRIPT WRITING FOR A CARTOON STRIP HE NEEDS ABSOLUTE SILENCE AND SOLITUDE, HOWEVER, WHEN DRAWING HE CAN PUT UP WITH ANY AMOUNT OF NOISE OR INTERRUPTIONS. HE LISTENS TO CASSETTES ALL DAY —— MAINLY MOZART, VERDI AND BEETHOVEN...

JACK NICHOLSON
Sunday Telegraph

I WAS QUITE SHOCKED WHEN HE TOLD ME HE WAS AMBIDEXTROUS — UNTIL HE EXPLAINED THAT IT MEANT HE COULD DRAW WITH BOTH HANDS AT THE SAME TIME.

HE CLAIMS THE RIGHT HAND HAS MORE CHARACTER

— ALTHOUGH THE LEFT HAND IS BETTER AT PERSPECTIVE AND IS MORE PROFESSIONAL

JOHN JENSEN CAME FROM AUSTRALIA IN 1949 AND WORKED ON THE BIRMINGHAM GAZETTE FOR THREE YEARS — THEN ON VARIOUS NEWSPAPERS DOING MAINLY POLITICAL CARTOONS — BUT NOT ANY MORE THANK YOU, HE SAID — GIVE ME A WIDER CANVAS FROM NOW ON, LIKE THE BOOK HE IS WRITING ON THE AUSTRALIAN CARTOONIST/ ILLUSTRATOR WILL DYSON.

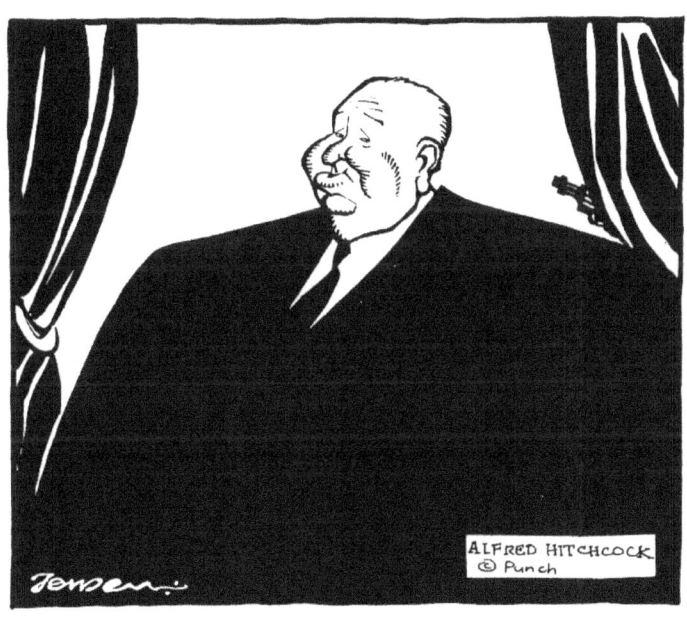

FRANK DICKENS LIVES AND WORKS IN HIS STUDIO FLAT ON THE THIRTY FIRST FLOOR IN THE BARBICAN, OVERLOOKING LONDON. HE IS AN EARLY RISER AND CLAIMS TO BE THE FASTEST CARTOONIST IN THE WESTERN WORLD. (HE'S NOT, BECAUSE I AM.) HE DOES A WEEK'S STRIP CARTOONS ON MONDAY LEAVING THE REST OF THE WEEK FREE (HE SAYS) TO DRINK, PAINT, WRITE AND GENERALLY DO AS HE PLEASES. ON MONDAYS — HE RISES AT FIVE THIRTY AND HAS AT LEAST SIX BRISTOWS AND SIX ALBERT HERBERT HAWKINS (THE NAUGHTIEST BOY IN THE WORLD) IDEAS DOWN BY THE TIME HIS SISTER ARRIVES BY 7.30 AM.

HE TRIES THE IDEAS OUT ON HER AND IF SHE LAUGHS HE PUTS THE IDEAS DOWN — THESE HE COMPLETES AS FINISHED STRIPS BY 11.0 AM. FRANK SAYS HE'S ALWAYS WORKED THAT WAY AND THEN HE DOESN'T HAVE TO EVEN THINK OF A CARTOON UNTIL HE GETS UP THE FOLLOWING MONDAY

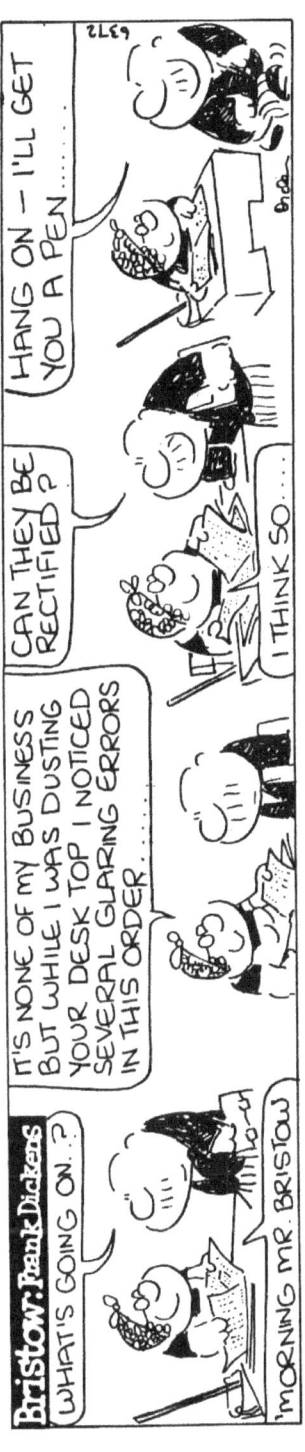
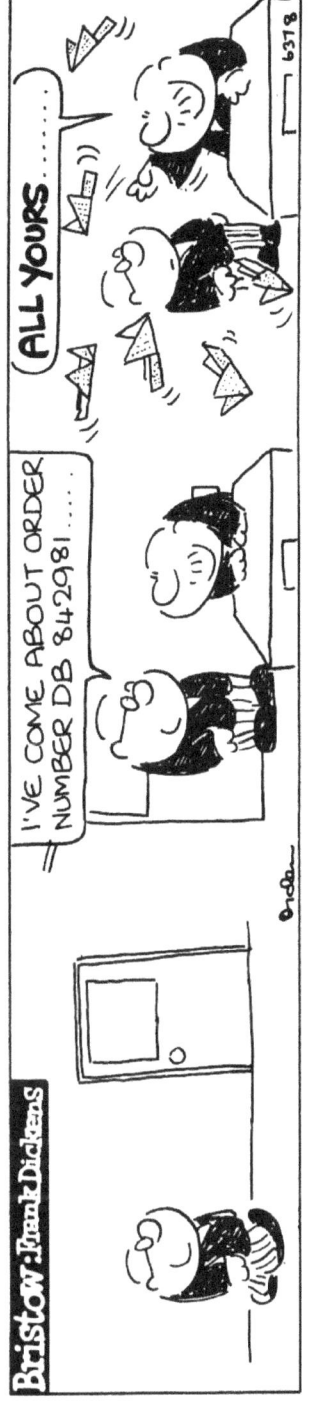
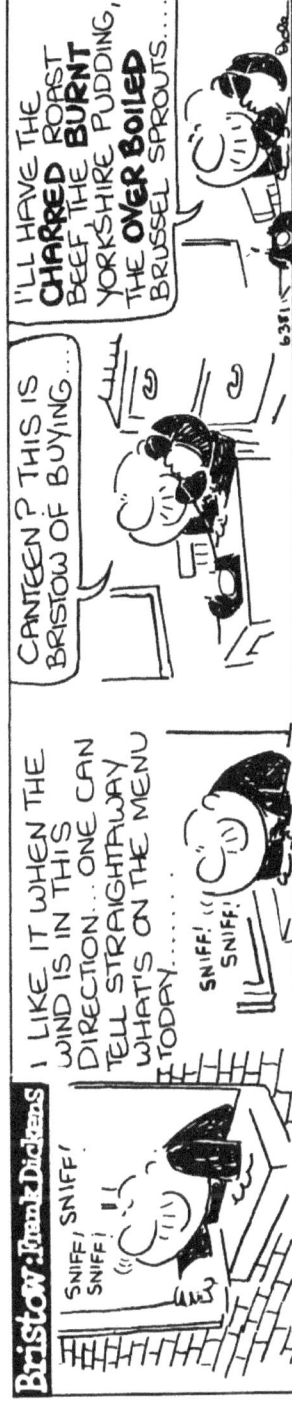

WORKING AT HOME DOESN'T WORRY HIM AT ALL— HE HAS A VERY FLASH DRAWING BOARD THAT IMPRESSES HIS VISITORS BUT PREFERS TO WORK ON HIS LAP; OR A TABLE OR ON THE FLOOR... ONE THING THAT IS CONSISTENT IS THAT HE ALWAYS USES CS10 FASHION BOARD, A DIP PEN (WHICH HE CLAIMS IS ONE OF MICHAEL HEATH'S CAST-OFFS), A NUMBER EIGHT RAPIDOGRAPH... AND PELIKAN INK (WHICH HE IS PRONE TO SPILLING.) HE VERY RARELY USES A PENCIL, USUALLY STRAIGHT IN WITH HIS PEN (NO ROUGHS) AND ENJOYS HIMSELF...

HE IS NEVER DISTRACTED BY NOISE OR PEOPLE, NOT EVEN EDITORS, BECAUSE AFTER RUNNING BRISTOW FOR TWENTY FOUR YEARS, WHATEVER HE PUTS DOWN IS USED WITHOUT CRITICISM— HE HAS WON AWARDS FOR HIS CARTOONING AND EVEN THOUGH HE IS FAMOUS FOR BRISTOW HE SOMEHOW STILL IDENTIFIES HIMSELF WITH ALBERT HERBERT HAWKINS (REMEMBER HE'S THE NAUGHTIEST BOY IN THE WHOLE WORLD — OR IS IT FLEET STREET?)

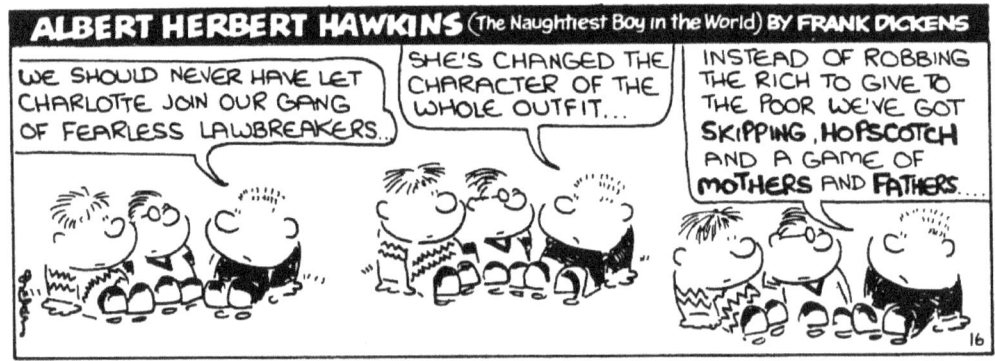

ALBERT HERBERT HAWKINS (The Naughtiest Boy in the World) BY **FRANK DICKENS**

- WE SHOULD NEVER HAVE LET CHARLOTTE JOIN OUR GANG OF FEARLESS LAWBREAKERS...
- SHE'S CHANGED THE CHARACTER OF THE WHOLE OUTFIT...
- INSTEAD OF ROBBING THE RICH TO GIVE TO THE POOR WE'VE GOT SKIPPING, HOPSCOTCH AND A GAME OF MOTHERS AND FATHERS...

ffolkes

MICHAEL FFOLKES MOVED INTO HIS 4TH FLOOR STUDIO ON THE FRINGE OF LONDON'S SOHO WHEN HE RAN OUT OF SPACE AT HOME SOME THIRTY YEARS AGO —— HE HAS WORKED THERE EVERY DAY SINCE THEN BUT NOWADAYS HE ALSO LIVES IN THE SAME BUILDING. ☞━━━━━━

HE DRAWS EIGHT REGULAR DRAWINGS EACH WEEK FOR THE DAILY TELEGRAPH AND ONE FILM DRAWING FOR PUNCH —— HE'S ALSO USUALLY ILLUSTRATING SOME BOOK OR A FULL PAGE COLOUR FEATURE FOR PLAYBOY MAGAZINE. HE SITS UPRIGHT AT HIS EXTRA LARGE DRAWING BOARD FROM TEN O'CLOCK TO FIVE THIRTY EACH DAY

—— AND IN EMERGENCIES RIGHT THROUGH THE NIGHT, THAT'S WHEN HE CLAIMS HIS STUDIO TAKES ON THE APPEARANCE OF A TORTURE CHAMBER WITH HIM AS THE VICTIM...

HE USES DALER BOARD OR DALER LANGTON WATER COLOUR PAPER AND HIGGINS BLACK INK WITH DR MARTIN'S COLOURED INKS (A GIFT FROM PAUL HOGARTH ——— THEY COME IN THIRTY FIVE COLOURS). GOD BLESS DR. MARTIN'S BLEED PROOF WHITE INK, HE SAID, HOLDING IT HIGH IN THE AIR —— THIS HAS SAVED MANY A DAY.
AND I'VE RECENTLY RE-DISCOVERED FOUNT INDECA IT FLOWS BEAUTIFULLY AND IS REASONABLY PERMANENT, HE SAID ——————— HE ALSO USES PENTEL PENS, PASTELS AND ANYTHING THAT MAKES A MARK.
HIS PEN IS THE ORDINARY DIP KIND WITH A PERRY DURABRITE NIB N°·16.

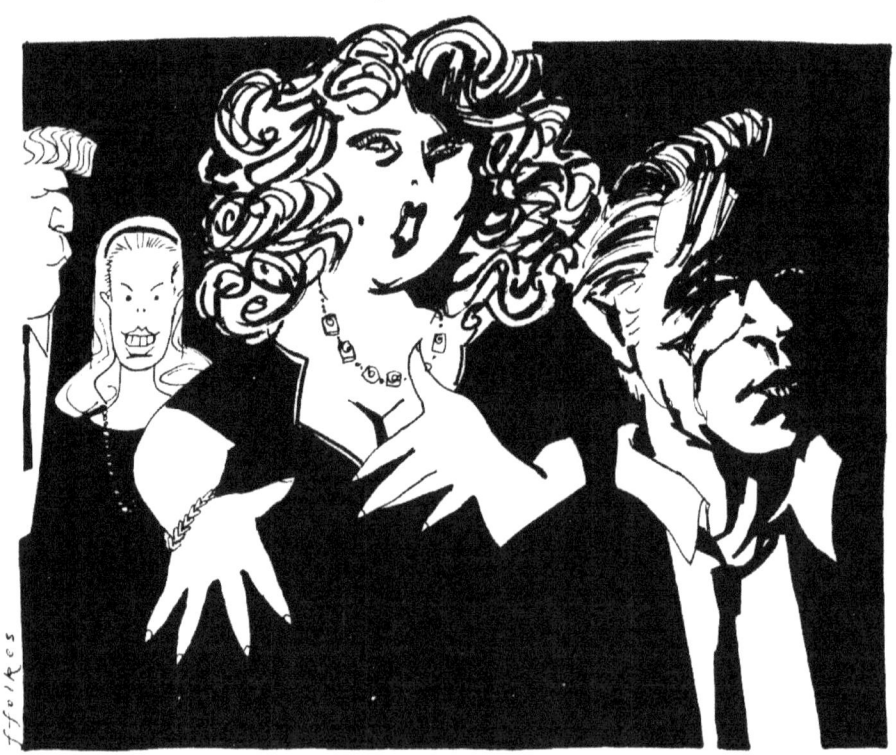

GEORGE SEGAL as Nick, SANDY DENNIS as Honey, ELIZABETH TAYLOR as Martha and RICHARD BURTON as George in Who's Afraid of Virginia Woolf.?

ALTHOUGH THE ACTUAL TELEGRAPH DRAWING TAKES ABOUT ONE HOUR TO DRAW HE TELEPHONES PETER SIMPLE BETWEEN ONE & ONE FORTY FIVE EACH DAY TO DISCUSS THE TEXT WITH MICHAEL WHARTON (WHO HAS A GOOD VISUAL IMAGINATION) AND THEY DECIDE ON THE SUBJECT TO ILLUSTRATE FOR THE FOLLOWING DAY...
LIVING WITH A FIVE THIRTY DEADLINE IS MURDER, HE SAYS, PARTICULARLY WHEN HE HAS TO CONSIDER HIS PUNCH FILM DRAWING EACH WEEK, AND THAT CAN TAKE ANYTHING FROM TWO TO SIX HOURS TO CREATE.
BUT HE INSISTS THAT IT'S ALL WORTH WHILE AND CLAIMS HE WOULDN'T WANT TO BE ANYONE ELSE.
HE ADMIRES, AND WAS GREATLY INFLUENCED BY, WALT DISNEY AND CONSIDERS HIMSELF TO BE A MEMBER OF THE WALT DISNEY GENERATION PLUS THE ADDED INFLUENCE OF STEINBERG, PONT AND EMMETT ALL OF WHOM HE HOPES HE HAS NOW CAST OFF BUT SAYS HE STILL LOVES LIKE BROTHERS.

"Long _knives_, you fool!"

Marc

MARK BOXER IS THE EDITOR OF TATLER MAGAZINE WHICH IS A FULL TIME JOB, AND HE HAS TO BE IN HIS OFFICE IN LONDON W.I. FIVE DAYS A WEEK —— HE FITS HIS CARTOONING IN THIS SCHEDULE. TRAVELLING FROM HIS HOME IN WEST LONDON EACH DAY BY CAR (MOTORBIKE DURING THE SUMMER) TO ARRIVE AT HIS OFFICE BY 🕙 TEN A.M. BY THEN HE HAS READ A COUPLE OF NEWSPAPERS IN HIS BATH, AND HAS ABSORBED OTHER POINTS OF NEWS FROM HIS CAR RADIO DURING THE JOURNEY. ☞ THEN HE MAKES WHAT HE CALLS A 'MENU' CARD OF POSSIBLE ITEMS (AROUND 5) AND TELEPHONES HIS FRIEND GEORGE MELLY AND THEN DISCUSSES THEM — THIS HE INSISTS SHARPENS UP THE IDEA — ALL THE BEST COMICS ARE DOUBLE ACTS, HE SAID...

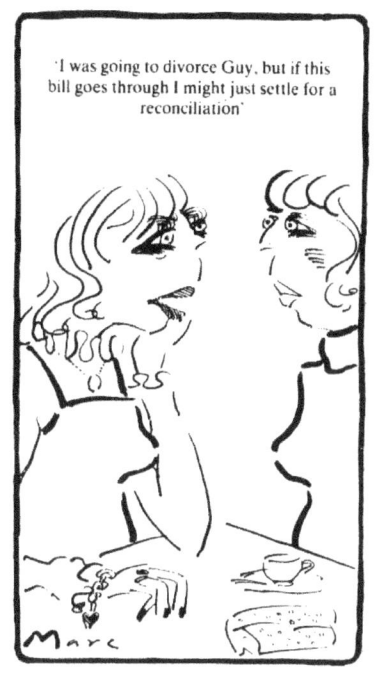

AT 3.15 PM HE STARTS TO DRAW AT A TABLE BEHIND HIS EDITOR'S DESK USING A4 CROXLEY SCRIPT PAPER AND A DIP PEN — GILLOT 404 NIB AND CALLIGRAPHIC INK.

HIS THICK LINES ARE DRAWN WITH A NUMBER 3&4 BRUSH. HE DRAWS TWO OR THREE ROUGHS USING OVERLAYS TO ALTER THINGS — THE CAPTION IS TYPED USING FRESH CARBON EACH TIME TO MAKE SURE OF A BLACK PRINT...

THE CARBON IS CUT SPECIALLY FOR HIM INTO 3 X 4 INCH PIECES AND KEPT IN A SMALL ENVELOPE NEXT TO HIS AMAZING OLD REMINGTON TYPEWRITER THAT ONCE BELONGED TO LORD THOMSON OF FLEET — IT HAS A VERY LARGE TYPE FACE AND HE USED IT TO TYPE HIS SPEECHES OUT BECAUSE HE WAS VERY SHORT SIGHTED.

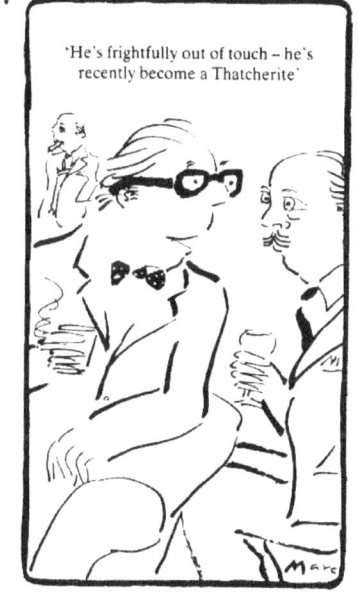

A MESSENGER ARRIVES TO PICK UP THE DRAWING AT FOUR THIRTY P.M. TO TAKE IT TO THE GUARDIAN ——— HE IS ADAMANT ABOUT KEEPING TO HIS TIME SCHEDULES; WORKING ON NEWSPAPERS AND MAGAZINES AS AN ART EDITOR AND FEATURES EDITOR HAS MADE HIM MUCH MORE UNDERSTANDING ABOUT PUNCTUALITY ———
MARK BOXER ADMITS TO BEING A WORKAHOLIC — HE DOES FOUR GUARDIAN CARTOONS AND ONE OBSERVER CARTOON PER WEEK PLUS A*SMIRNOFF (VODKA) CARTOON PER FORTNIGHT (CHEERS)
HE WAS MOSTLY INFLUENCED BY OSBERT LANCASTER, PONT AND STEINBERG (CHEERS AGAIN).

*THIS IS A REGULAR ADVERTISING FEATURE

'I take it Egon Ronay has gone then?'

Stanley McMurtry is Mac's real name and he has recently moved to live in Ipswich, so now he only travels up to Fleet Street on Sundays and Thursdays — and because he draws a cartoon every day in the Daily Mail, he has acquired a computerised facsimile machine that can transmit his artwork from his home to the computer in the Mail office —— if this catches on it could close every pub in Fleet Street...

MAC DOESN'T LISTEN TO THE NEWS BEFORE LUNCH, HE PREFERS TO READ ALL THE PAPERS BECAUSE HE FEELS THEY ARE FAR MORE INDICATIVE OF THE NEWS TRENDS FOR THE FOLLOWING DAY WHEN HIS CARTOON APPEARS. HE ROUGHS OUT IDEAS ON A2 LAYOUT PAPER IN PENCIL — AT LEAST FOUR OR FIVE — SENDING THEM THROUGH THE COMPUTER TO SHOW THE EDITOR. MAC SPEAKS TO THE EDITOR BY PHONE TO GET AN IDEA CHOSEN. AFTER LUNCH HE SETS TO WORK ON THE FINISHED ARTWORK — HE USES ART LINE BOARD N°3 IN HALF IMPERIAL SIZE...

'It's Mrs Mayhew again — ¼lb. of streaky, a packet of Typhoo and she hasn't got all night . . .'

FIRST HE PENCILS IN AS MUCH DETAIL AS HE CAN BECAUSE HE FEELS HE OWES IT TO HIS READER TO MAKE HIS WORK AS DETAILED AS POSSIBLE AND TO MAKE USE OF ALL THE SPACE.
MAC USES LOTS OF REFERENCE FOR BOTH THE CARICATURES AND THE BUILDINGS. DRAWING THE FINISHED LINE WITH A GILOT 404 NIB AND BLACK PELIKAN INK — 2½ TO 3 HOURS LATER HE ADDS THE TONE IN BLUE INK THEN COVERS THE DRAWING WITH KODATRACE GOING OVER THE TONE AREAS ON THIS IN BLACK INK — THIS ENABLES THE PRINTER TO DOT TONE THE DRAWING FOR PRINTING WITHOUT SPOILING THE ORIGINAL.

'At first the television companies just didn't want to know....'

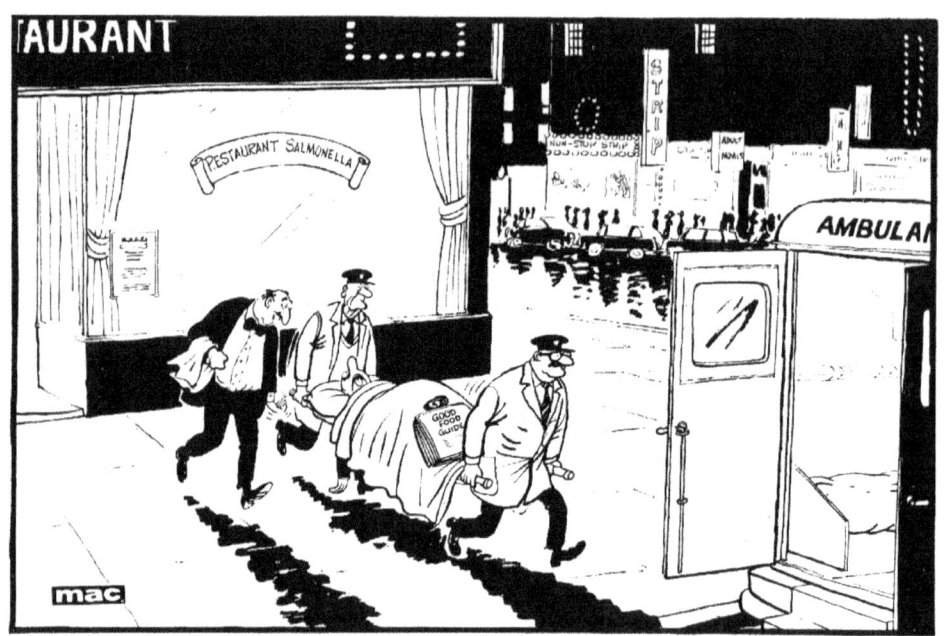

'I hate to remind you sir, but a service charge was not included...'

Mac always draws his wife in his cartoons. She's in there somewhere, on a sign, a board, a poster or in a shop window or just blended into the background detail — he says his readers worry if they can't find her, recently she has looked a little plumper than usual — the readers want to know if she is pregnant?. Besides the Mail, Mac draws for Punch, advertising and greetings cards...
He considers himself very fortunate to be able to draw cartoons for a living, he couldn't imagine doing anything else — besides, what else could he feed into that computer?

MADDOCKS

I INCLUDE MYSELF IN THIS BOOK NOT BECAUSE I CONSIDER MYSELF 'SUPER' BUT BECAUSE IT'S **MY** BOOK—AND THAT'S WHY I'M IN IT.

I WORK FOR LOTS OF NEWSPAPERS AND MAGAZINES FROM MY OWN LITTLE STUDIO OVER THE FAMOUS EL VINO'S WINE BAR IN FLEET STREET.

I DRAW THE NUMBER 10 CARTOON STRIP FOR THE SUNDAY EXPRESS...

BECAUSE IT'S A TOPICAL STRIP I SUBMIT THREE ROUGHS TO THE EDITOR, USUALLY ON THREE ITEMS IN THE NEWS — THESE ARE QUITE DETAILED ROUGHS BECAUSE WITH MY STYLE OF DRAWING MY ROUGHS ARE NOT FAR REMOVED FROM MY FINISHED ARTWORK — I DRAW THIS FEATURE WITH A BLACK PARKER FIBRE TIP PEN ON CARTRIDGE PAPER...

3. ROUGHS:

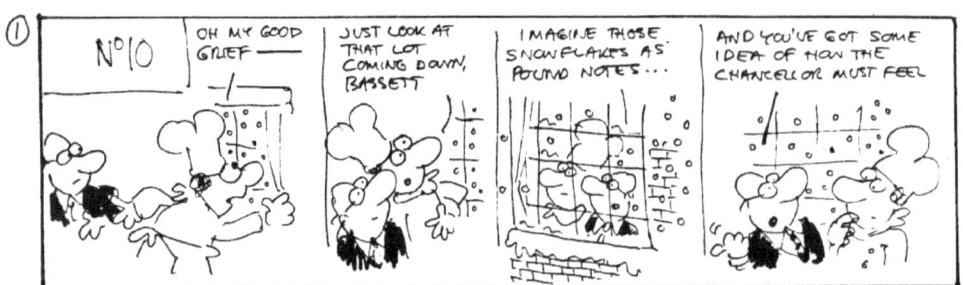

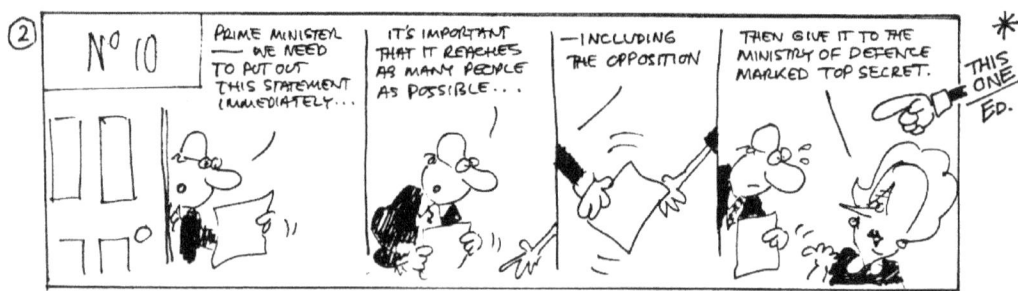

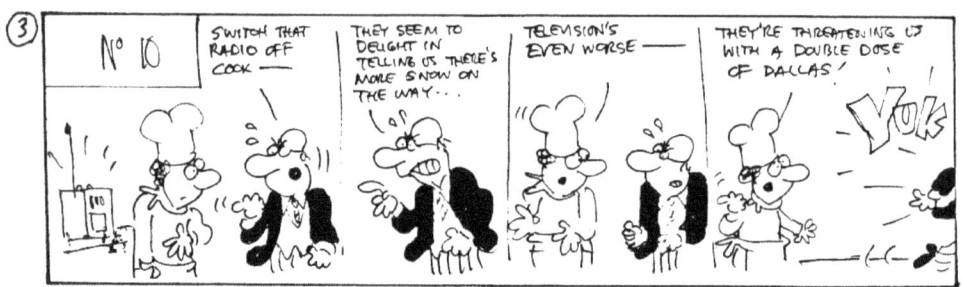

* FINAL ARTWORK:

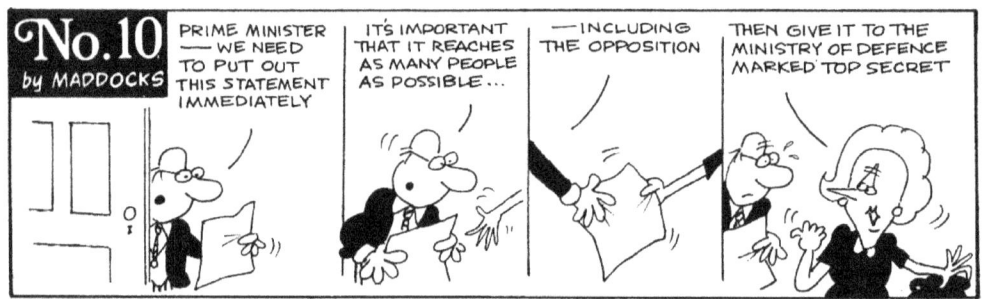

FOR COLOUR WORK I USE DR. PH. MARTIN'S CONCENTRATED WATER COLOUR — THEY COME IN BOTTLES LIKE INKS, A BEAUTIFUL RANGE OF COLOURS IDEAL FOR THE STRIP CARTOON PAGES

ON SATURDAY MORNING I DO THE FRONT PAGE TOPICAL CARTOON IN THE SUNDAY EXPRESS — I SUBMIT THREE FINISHED DRAWINGS AND NOT ROUGHS FOR THIS FEATURE, BECAUSE AN EARLY CHOICE BY THE EDITOR ENABLES ME TO GET AWAY BEFORE MIDDAY. (CRAFTY)

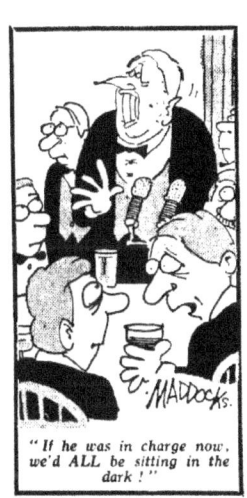

"If he was in charge now, we'd ALL be sitting in the dark!"

OCCASIONALLY I STAND IN FOR THE FEATURE PAGE POLITICAL CARTOON —

THIS IS A LIFETIME'S AMBITION FULFILLED BECAUSE I ALWAYS WANTED TO BE A POLITICAL CARTOONIST — AND THE FREEDOM OF DRAWING FOR FOUR COLUMNS IS A JOY.

IT'S A CRAZY BUSINESS —
BUT VERY EXCITING AND STILL YOU HAVE
TO GET INTO BED EVERY NIGHT TO
SLEEP —— EIGHT HOURS — **WASTED**.

ACKNOWLEDGEMENTS TO:

THE TIMES · THE GUARDIAN · THE STANDARD
THE DAILY EXPRESS · THE SUNDAY EXPRESS
THE DAILY MIRROR · THE DAILY TELEGRAPH
THE OBSERVER · THE SUN · THE DAILY MAIL
PUNCH · PRIVATE EYE · THE SUNDAY TIMES
THE MAIL ON SUNDAY · METHUEN LONDON LTD
EYRE METHUEN LTD · PATRICK HARDY BOOKS
THE SALAMANDER PRESS EDINBURGH LTD
LINUS · GERRY LIP OF EXPRESS NEWSPAPERS

A little about the Author, Peter Maddocks, Fleet Street Cartoonist, and children's film maker, now resides in southern Spain. In the Last few years he began to release his many 'How to draw books' all available in paperback and eBook formats. He also writes short stories for children, and adults.

He spends a great deal of his time, drawing, and painting in his many styles.

Please find examples of his work at

petermaddocksart.com

PublishedByMe.blogspot.com

www.ingramcontent.com/pod-product-compliance
Lightning Source LLC
Chambersburg PA
CBHW080713190526
45169CB00006B/2353